POSTCARD HISTORY SERIES

Savin Rock
Amusement Park

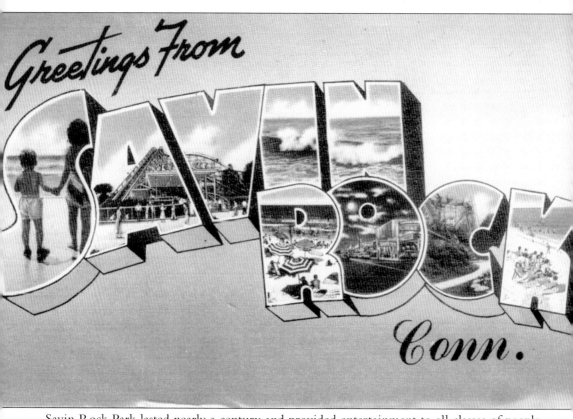

Savin Rock Park lasted nearly a century and provided entertainment to all classes of people throughout the southern New England region.

On the front cover: Savin Rock Park in West Haven, Connecticut, provided nearly a century of family entertainment in a quiet town nestled along New Haven Harbor. (Courtsey of Ronald T. Guerrera collection.)

On the back cover: Installations, like the White City, helped introduce the wonders of 20th-century technology to the public. (Courtsey of Ronald T. Guerrera collection.)

POSTCARD HISTORY SERIES

Savin Rock Amusement Park

Edith Reynolds

Published by Arcadia Publishing
Charleston SC, Chicago IL, Portsmouth NH, San Francisco CA

Printed in the United States of America

Library of Congress Catalog Card Number: 2005937186

For all general information contact Arcadia Publishing at:
Telephone 843-853-2070
Fax 843-853-0044
E-mail sales@arcadiapublishing.com
For customer service and orders:
Toll-Free 1-888-313-2665

Visit us on the Internet at http://www.arcadiapublishing.com

CONTENTS

ACKNOWLEDGMENTS

No project comes to completion without recognizing how much work is involved and the assistance given by others. This project was no exception.

Without Ron Guerrera's postcard archive of Savin Rock, this book would not be possible, and I thank him for his patience and help throughout the writing. The postcards seen in this book are from his personal collection and from the archives of Mattatuck Antiques, a Waterbury shop he owns and operates.

I am most especially grateful to my family and our bookshop staff. My husband, Dan, kept the bookstore running during the times when I was working on the book. My daughter Sarah helped in caring for her nephew and my grandson, Thomas, throughout. Our loyal employees Liz and Vicky Semrow scanned and rescanned postcards until they could not see straight. Our technology manager, Terry Scully, tried to help make that process easier.

Overall, the legacy of Savin Rock would not have been as easy to research if it had not been for the contributions made by some wonderful West Haven locals who kept the memories alive. First and foremost are Harold Hartmann and the staff at the Savin Rock Museum, next to the rock itself. The museum is a grand way to spend some time by the shore, and the entire staff is delightful and most informative. Another major contributor is Bennett Dorman, a local historian who compiled memories of Savin Rock from past workers, neighbors, and the like.

A special consideration is due to John Moriarity of Middlebury for sharing his own special memories of Savin Rock and for providing research materials. Another thank-you goes to Fred Chesson, who shared his own memories with me.

And my own memories of Savin Rock I owe to family. My cousin Jo-Ann Ford Poulsen reminded me of so many promotion days spent with our mothers, and I am grateful for so many special summer afternoons spent on Prospect Beach with my grandmother Eleanor Reynolds and my aunt Dot Clark Reynolds.

INTRODUCTION

My earliest memory of Savin Rock began in a Prospect Avenue home when I was a toddler. My teenaged uncle Bob and I had dinner with my Aunt Dot and Uncle Jerry, and on the menu were baked kidney beans. This was a thoroughly unappealing side dish as far as Bob and I were concerned, and we anticipated the meal with dismay.

Bob leaned sideways when the plate was laid on the table and said inquisitively, "You're feeling sick?"

Before I could answer, Bob hurriedly explained that my stomach was upset, and he needed to get me home without delay. Within an instant and despite quite a lot of protesting that I looked just fine, Bob and I were in the car and driving away.

I had not realized I was sick, but Bob, being the adult, perhaps knew better.

Imagine my surprise, therefore, when Bob stopped the car on Beach Street outside the Flying Horses. Instead of choking down baked beans, I was whirling the night away on a magnificent steed rising and falling in time to the heady calliope music. With Bob grabbing one brass ring after the next, the fun was not likely to end too soon.

Dinner was a palatable mix of honeyed popcorn, glistening candy apples, and a steaming Rosseler hot dog coated in yellow mustard.

I did not know then that Savin Rock was in its demise and the wondrous world of light and sound along with its delicious smells would be bulldozed to raw ground. The end was 10 years away, and that night I was in my glory and enjoying every second of a special evening out.

When we finally reached my house in New Haven, my worried parents met us at the stairs. My aunt had called hours ago to report that I was sick.

As my mom stared at my sticky face and tousled hair, she announced, "If she wasn't sick earlier, the flying horses and all that candy will do the trick tonight."

My uncle shrugged and sheepishly explained, "Dot was serving those beans."

Savin Rock was a place of escape for so many who lived in southern New England. For the latter part of the 19th century, the park provided a place of retreat and enjoyment, whether you lived a life of luxury or worked long hours in a hot factory. Each decade brought new attractions to the park and new generations of people looking for fun.

When the amusement park fell victim to urban renewal, it was the end of an era for West Haven, but even now that the landscape is entirely different, I can still recall the "laughing lady's" howl echoing through the still night air.

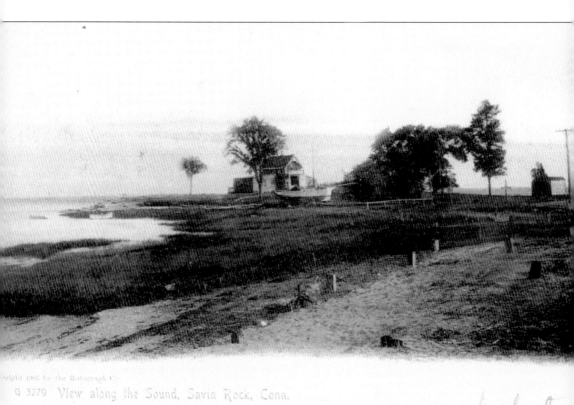

G 3279 View along the Sound, Savin Rock, Conn.

Small homes belonging to beach-loving families speckled the western shore of New Haven Harbor in Connecticut. A little farther inland, the homes belonged to farms, and these were claimed as a part of the town of Orange. The shoreline, however, belonged to New Haven until 1921 when West Haven was formally incorporated.

One

THE WEST SHORE

Savin Rock rests along the west shore of Connecticut's New Haven Harbor. It is a gentle shore warmed by the Gulf Stream and protected by Long Island Sound from the worst of the Atlantic Ocean storms.

The first European settlers arrived in 1638 when John Davenport left the Massachusetts Bay Colony to set up a trading post. The newcomers marveled at the bounty awaiting them. The waters beneath teemed with oysters, clams, and mussels as well as an array of edible fish, and a native encampment of Quinnipiacs sat at the top of the promontory, surrounded by fertile fields.

The small wooden ship sailed up past the feeding West River and into the currents of the Quinnipiac and Mill Rivers. This was a sheltered, deepwater harbor, and as they progressed, the settlers turned to the opposite shore. The western coast was low and marshy, broken only by a single rock jutting skyward that the settlers dubbed Savin Rock because the low vegetation covering it was reminiscent of similar trees from home.

Davenport's aim was to enlist the friendly Algonquin Quinnipiacs as trappers while the white settlers developed a Puritan community fueled by a rich export trade. From the start, however, almost none of Davenport's plans went right.

First among the obstacles was learning that the Quinnipiacs did not suffer immediate hardship. In summer they feasted on the bounty of the water while their crops matured. In winter they moved inland and lodged in longhouses, living off game, much as they had for thousands of years.

The Dutch contributed to the travails of Davenport because they maintained a claim upon Connecticut, seeing it as a natural extension to their settlement in New Amsterdam (New York City). An English outpost, blocking their passage along the protected sound, forced their trading vessels to navigate Long Island's more treacherous southern coast, and so they decreased their risk by blockading Davenport's band within the harbor. No trading ships came or went, making starvation over the long, hard New England winter a real possibility.

Quinnipiac generously ceded what is now the New Haven Green to the colony, and soon crops were sowed. The natives then taught the newcomers how to pull immediate sustenance from the water. In time, the English colony thrived and spread beyond the original nine square plots in New Haven's center and turned the forests into usable farmland.

The western shore lay a mere four miles from the green and remained largely undeveloped during the long years of blockade. Later, following the Revolutionary War and leading up to the War of 1812, Savin Rock served as a lookout point, thus providing the area's only natural use.

New Haven was a prosperous town despite its early hardship. It served as a co-capitol with Hartford in the beginning, and before the remaining Quinnipiacs moved inland toward Farmington, its friendly relations between the two disparate cultures marked the community. It was learning rather than trapping that earned New Haven's reputation, and it was the deep reach of the harbor that earned the city its wealth.

Copyright 1905 by the Rotograph Co.
Elm St. from Church St, New Haven, Conn.

The town was perfectly suited to succeed in the Industrial Revolution. It had a good port, a reliable rail system, old money, and education. Until the latter part of the 20th century, New Haven was a prosperous, bustling city that promised continued growth.

10

Many of the nation's wealthiest families sent their children to New Haven to study at Yale. New Haven became a temporary home to future presidents, corporate leaders, and artists. Relaxation away from the classroom was a car ride away from the green where one could bask by the shore eating fresh seafood.

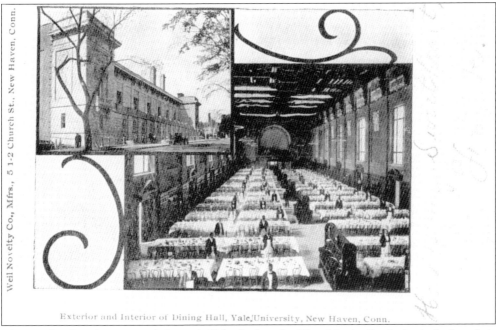

Exterior and Interior of Dining Hall, Yale University, New Haven, Conn.

Thousands of students passed through Yale during the life of Savin Rock, both during their school years and afterward. Savin Rock was the most accessible area for relaxation at that time and a favorite gathering spot for alumni reunions.

New Haven followed the rest of the nation by industrializing. Large factories soon demanded a growing number of workers, and those were gleaned from the exodus of immigrants leaving Europe. In a short time, a large working-class population arose with small amounts of money to spend on entertainment. The majority of the workers were families who appreciated a day in the sunshine where they could eat, play, and relax.

CANAL DOCK, NEW HAVEN, CONN.

The east shore of New Haven was entirely different from the more tranquil western side. Throughout the lifespan of Savin Rock, the harbor was a busy port. In the 19th century, there were plans to construct a canal inward toward Farmington. It was a time of expansion and growth with a future full of promise.

Two

KELSEY'S PLAN

The father of Savin Rock Park was indisputably Col. George Kelsey, who served during the Civil War with the 6th Regiment of the Connecticut Volunteers. Kelsey was a go-getter who made his fortune in the postwar industrial boom. By the 1870s, he held a controlling interest in the newly proposed horse-drawn rail trolley system, and this led to the development of what would become one of the first and finest amusement parks in New England.

Kelsey was a true entrepreneur to the core and carefully planned the Savin Rock community with a canny sense of development. Not wanting to limit transportation to a rail trolley system alone, Kelsey embarked on the construction of a 1,500-foot pier jutting out into the harbor that provided a ferry port not dependent upon the tides.

Next he built the Sea View Hotel, a true Victorian mansion that provided "the waters" for up to 150 wealthy patrons at a time. Their stay was made more pleasant by a grove of elms that supplied a shady park with wide swaths of promenades that stretched out around the shore side of Savin Rock to the small spit of land called Bradley Point. The opulent hotel was soon filled with people willing and able to spend their money, and Kelsey had no problem encouraging other businessmen to develop amusements designed to keep his customers happy. Consequently a small zoo, a museum, and dance hall soon burgeoned within the park.

Kelsey foresaw the truly wealthy patrons would always be on the lookout for something new and fresh, and so Kelsey's patrons soon found themselves mingling with a more middle- and working-class crowd who derived its money and leisure time from the prosperity of local factories like Sargent, Cowles, Bassett, and Winchester Repeating Rifles in New Haven. Surges of Irish, Italian, and Polish immigrants who flooded New Haven to fill the growing need for able hands took advantage of the easy access to Savin Rock.

Piers cropped up along the shoreline to accommodate fishing and boats. This pier stood at Prospect Beach until the mid–1960s, when neglect made it too dangerous to stand.

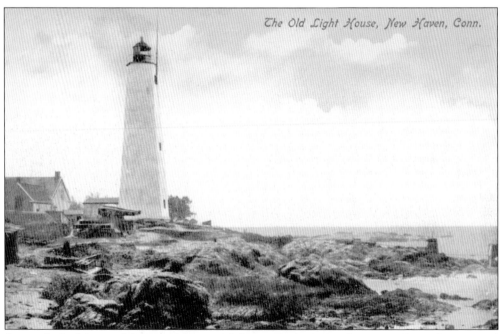

The Old Light House, New Haven, Conn.

Across the harbor stood the New Haven Lighthouse. As Savin Rock prospered, similar piers and an amusement park were constructed with continuous ferry service linking the two sites.

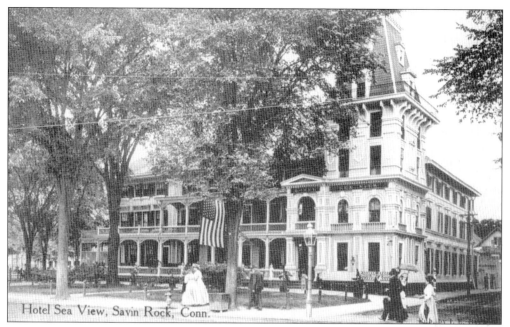

The Sea View Hotel created by Col. George Kelsey was the area's most elaborate and was built in stages. The tower was the last portion erected. The bunting is indicative of Kelsey's deep patriotism, and it was said that a large part of the hotel's success came from the host's presence when guests arrived. Kelsey had a magnetic personality that was perfect for the times.

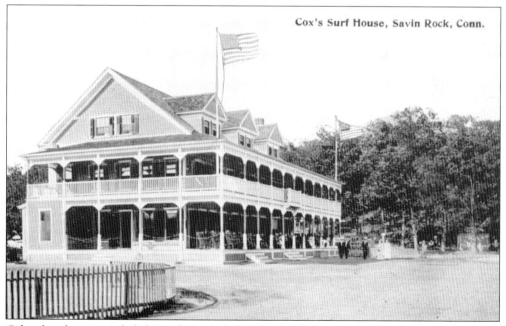

Other hotels surrounded the park, capitalizing on the flow of people brought to the area by Kelsey's enterprises. Cox's and the others offered short- and long-term stays for tourists until the 1930s.

Hotels ranged in quality from the elegant Sea View to more bed-and-breakfast-style guesthouses. This enabled the wealthy and the middle class to enjoy the same advantages of seaside amusement.

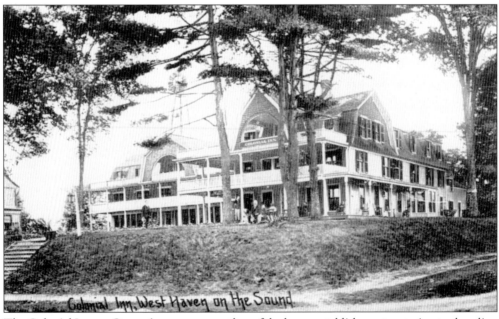

The Colonial Inn on Ocean Avenue was another of the larger establishments catering to shoreline visitors and featured its own trolley stop.

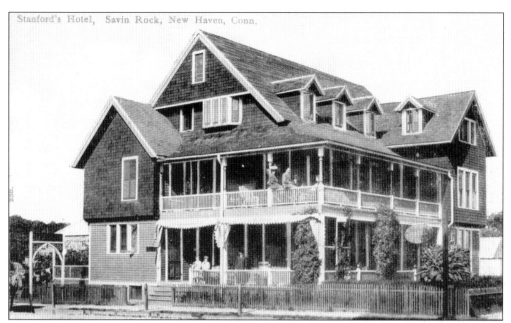

Stanford's Hotel was another of the more modest accommodations in Savin Rock. Wide verandas allowed patrons to sit in the late afternoon to enjoy the offshore breeze.

West Haven's center was a short walk from Savin Rock and was the site of Connecticut's oldest Episcopal church.

A 5393 Congregational Church, West Haven, Conn, *Little James's church*

The town green was nearly picture-perfect and identical to most Colonial town centers with a Congregational church dominating the landscape.

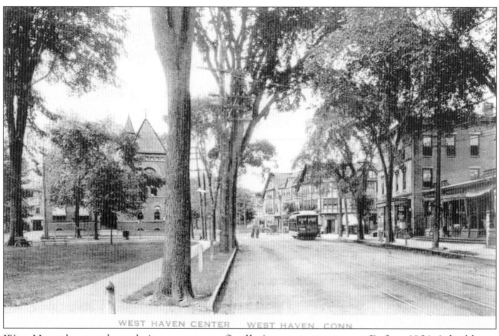

WEST HAVEN CENTER WEST HAVEN, CONN

West Haven's growth made it necessary to finally incorporate a town. Before 1921, it had been considered a part of Orange, and before then it had been segmented as portions of New Haven and North Milford.

Three

THE GROVE

Kelsey's grove began to take on a personality of its own rather than as an extension of the nearby hotels. Large trees overhung a grassy plain that was cooled each evening with offshore breezes. From the shoreline to the small center of West Haven, the grove provided plenty of room for families to stretch out and enjoy a day of feasting outdoors, enjoying the traditional picnic-style games of horseshoes, sack races, and the like.

In time, pavilions were added, then lush gardens, a fountain, and bandstand became a part of the permanent landscape. Small souvenir stands and food kiosks providing special treats like honeyed popcorn, cotton candy, and other sweets created a stable seasonal income for enterprising locals. It is reported that Savin Rock was where the lollipop (or taffy on a stick as it was called) was invented.

Even the newly formed game of baseball found a home at the park, one diamond being replaced by ones larger and grander until Donovan Field was erected. It was here that the local Colonials competed against nearby teams like the Yankees, whose team player Babe Ruth was known to round the bases. Later football and midget stock car racing were added to the venue.

The crowded ferries offered the first of many opportunities for lonely immigrant lads and lasses to strike up a friendly conversation. Julia O'Sullivan and Patrick Moriarity were a typical example. When the young Irish-born maid embarked the ferry at Lighthouse Point for a day at the beach, the crowded conditions forced her against the rail. She was grateful, therefore, when a young, handsome factory worker from Waterbury offered her a seat. When Moriarity casually mentioned that the harbor reminded him of his former home in Tralee, Julia O'Sullivan's interest was captured.

Within a short time, the young domestic had taken up residence in Waterbury as Moriarity's new bride, and to this day, when their descendants dine at Jimmies Restaurant in Savin Rock, they look out over the water and think about the short boat ride that gave their family its start.

The grove began as a simple affair with wide ample lawns for walking under the trees. When Col. George Kelsey and other entrepreneurs began exploiting the area, amusements were of a simple nature. Within the parklike area, Kelsey and others constructed a zoo as the first attraction.

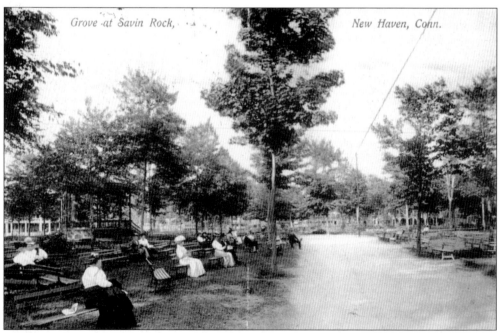

Grove at Savin Rock, *New Haven, Conn.*

In time, wide swaths of walkways crisscrossed their way through the park and around Savin Rock. Guests at the hotels could mingle freely, spending hours conversing in the shade.

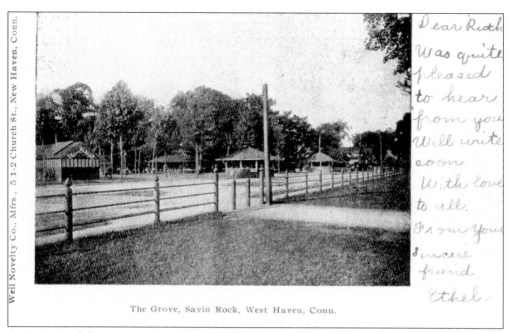

Dear Ruth
Was quite
pleased
to hear
from you
Will write
soon.
With love
to all.
From your
sincere
friend.
Ethel.

The Grove, Savin Rock, West Haven, Conn.

As Savin Rock became more egalitarian, it became less an extension of the nearby hotels. It was not long before wooden concessions were erected to sell a variety of objects and foods, thereby creating a seasonal income for nearby families.

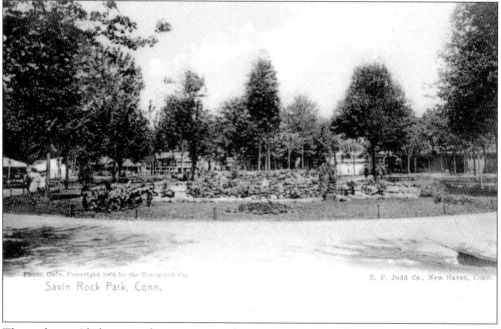

Photo. Only. Copyright 1905 by the Rotograph Co.
E. P. Judd Co., New Haven, Conn.

Savin Rock Park, Conn.

The park provided a genteel environment that was open to all, both the gentry and working class alike. Amenities like a luxurious rock garden and fountain were added to keep the place looking fresh and appealing.

21

The grove provided a shady respite throughout the summer season. The summer, in Connecticut, begins on Memorial Day in May and ends with Labor Day in September. The warm days and temperate water last into October, however.

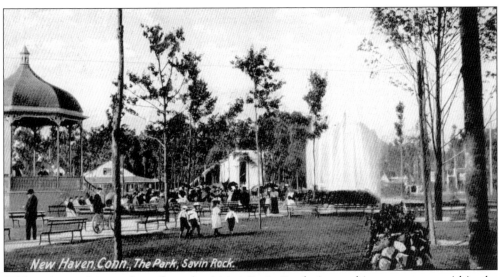

New Haven, Conn., The Park, Savin Rock.

With an increasing number of people visiting Savin Rock, internal improvements within the grove began to take shape. A band shell soon joined the rock garden and fountain.

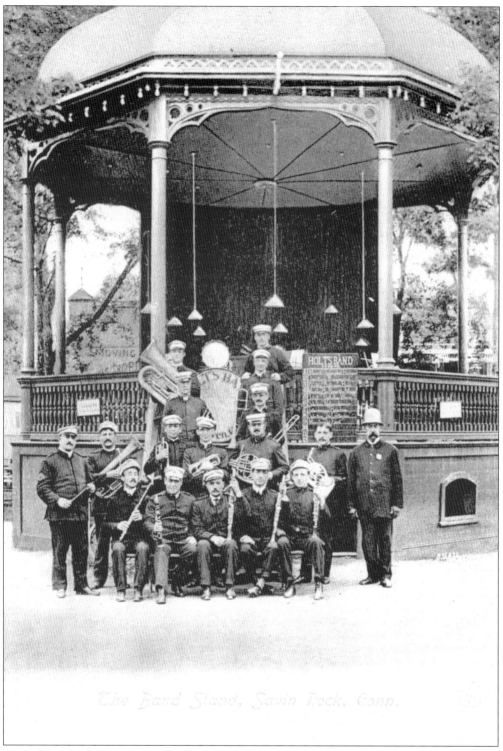

One of the problems associated with the live bands was that, while the band was protected from the elements, the overhanging trees did little to keep concertgoers dry.

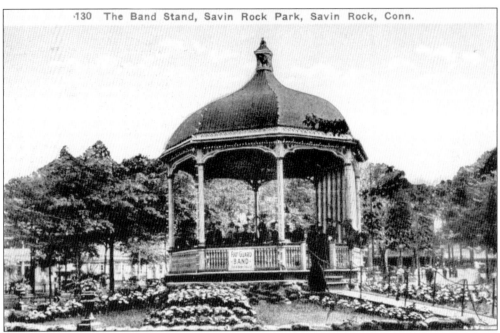

Col. George Kelsey's band shell was put to use season after season with handsome performers decked out in uniform playing the latest tunes. This was the beginning of live entertainment at Savin Rock. Their success goaded park owners to forgo local entertainment in favor of traveling acts and professional performers.

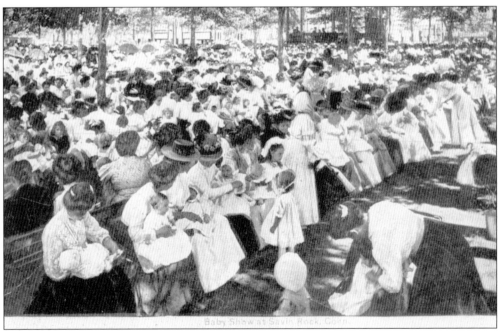

Events like this baby contest were designed to bring visitors to the park. The success of the park enabled the surrounding town to grow, drawing in families to the region. Day excursions for locals were a staple part of living along the shore.

Elm Street, West Haven, Conn.

The infrastructure of what became West Haven began to take shape. Neighborhoods were constructed, and streets were eventually lined with trolley tracks.

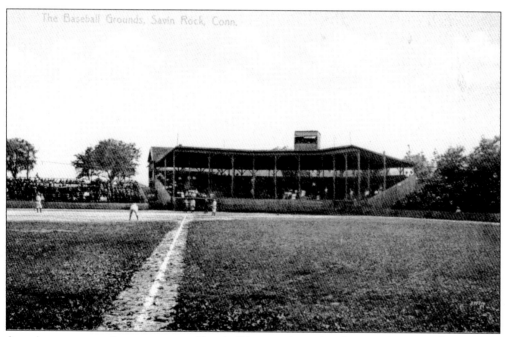

The Baseball Grounds, Savin Rock, Conn.

America was a growing country, and baseball became its national game. Savin Rock contained several different ballparks in its day, but Donovan Field was its most elaborate and longest lasting. As baseball waned in popularity, other attractions like midget race cars were added to the bill.

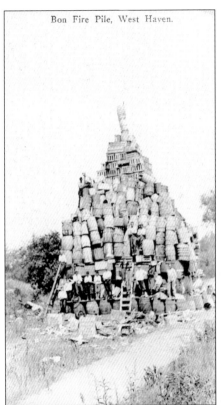

Bon Fire Pile, West Haven.

Initial entertainments were all-American like the annual bonfire for the Fourth of July. This one of barrels was typical of the day. Today's holiday entertainment is a dazzling fireworks display over the harbor.

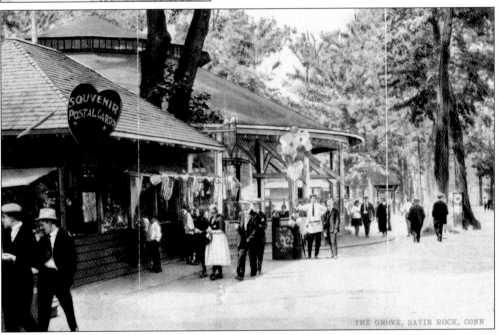

THE GROVE, SAVIN ROCK, CONN

The addition of structures to the grove provided many ways to spend money. Families visiting Savin Rock often acquired souvenir trinkets. Some were simple postcards, others more elaborate. Spice racks, anniversary clocks, and stuffed toys filled the kiosks.

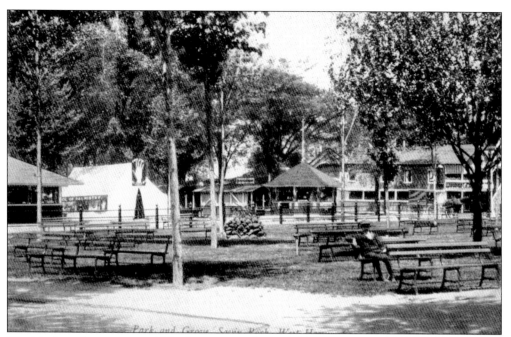

The kiosks and structures within the grove multiplied, filling in the shady park with more and more opportunities to spend money.

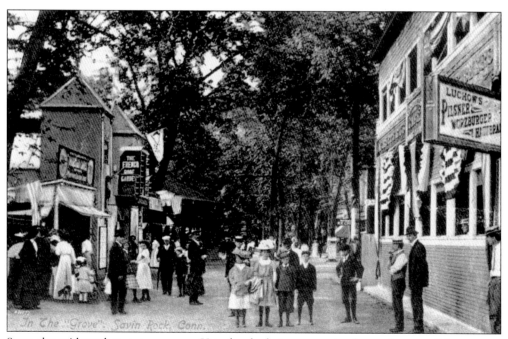

Soon the midway began to emerge. Yet, the shade trees remained a staple part of the scenery and offered respite from the summer sun.

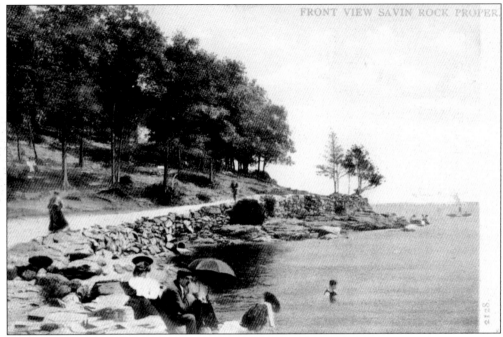

The grove's outlying region stretched out along Beach Street, and visitors could travel around the rock toward Bradley Point. A pleasant walk was constructed on the shore side of the rock. Sea bathers could swim here at high tide.

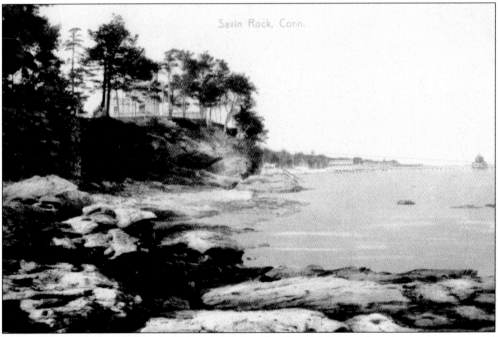

Savin Rock, Conn.

Col. George Kelsey capitalized on the rock being the shore's highest elevation and constructed an observatory. Nearby hills leading up from Ocean Avenue were higher still, but Kelsey's aim was more entertaining than scientific.

28

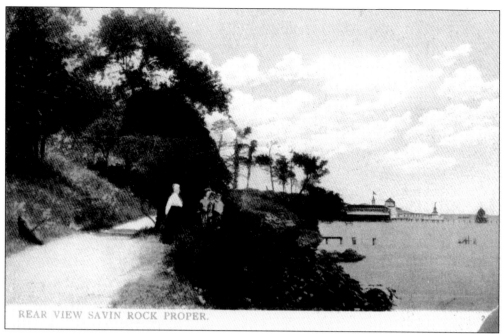

REAR VIEW SAVIN ROCK PROPER.

At times the walkway was quiet, making it a perfect place for young couples to spoon. This became a traditional lovers' lane.

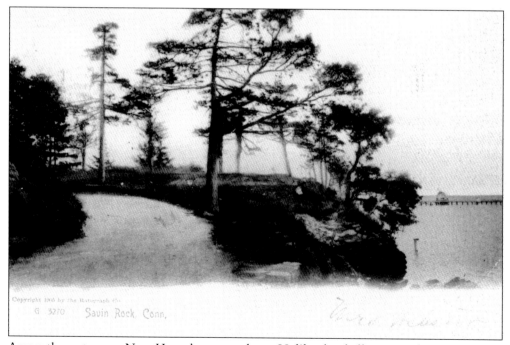

Savin Rock, Conn.

Across the water was New Haven's eastern shore. Unlike the shallow west shore waters, the opposite side had deepwater landings and a lighthouse. This side had a muddy flat that made it safe for waders, but ferry slips needed to stretch far into the water.

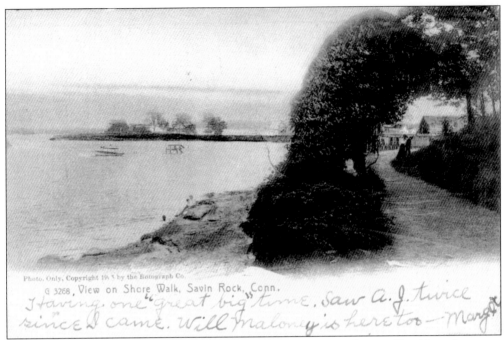

G 3268, View on Shore Walk, Savin Rock, Conn.

Having one "great big" time. Saw A. J. twice since I came. Will Maloney is here too — Marg

On the opposite side of the rock, Bradley Point stretched a narrow finger of land into the water. Here small cottages were erected and often housed relaxing Yale students and professors. One private home was converted into the Barnacle restaurant in later years.

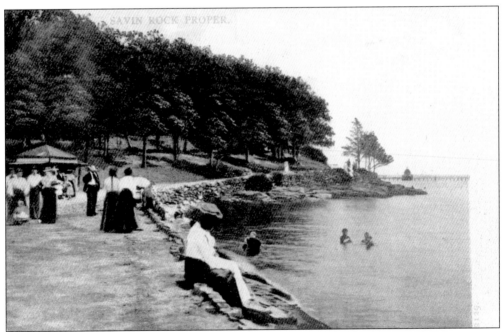

SAVIN ROCK PROPER.

Like most of the rocks in the vicinity, the rocks here were barnacle encrusted, and every crevice was filled with shells cracked by seagulls. Even the muddy flat below the water was littered with small black snails and an occasional horseshoe crab.

30

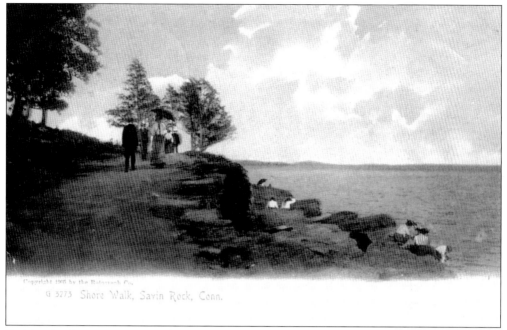

G 5273 Shore Walk, Savin Rock, Conn.

Bathing in the water was not the primary reason people first came to Savin Rock. The only real beaches were north and south of the amusement area. The shoreline at the rock itself was rocky but free to use.

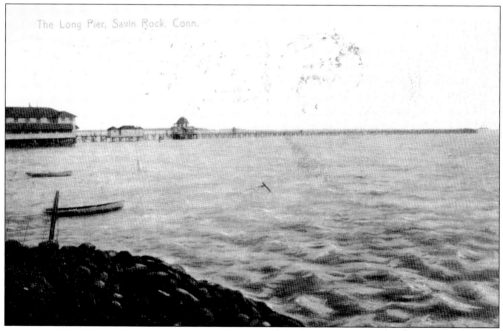

The Long Pier, Savin Rock, Conn.

Growth was the keyword for the era between the Civil War and World War I. Long piers, small cottages, and plenty of commercial enterprises capitalized on the natural attraction of the beach. This one reached well past the low tide mark and contained money-making enterprises between the docking point and shore.

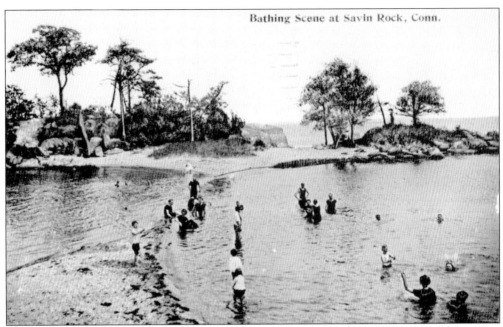

The salty waters of New Haven Harbor provided a favorite "watering spot" for locals and visitors alike in 1911. Many in the water are sporting bathing suits. The shallow depth meant that swimming was relegated to high tides.

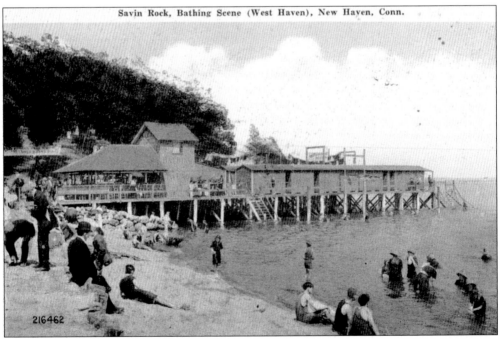

Visitors to the park were soon presented with bathing sheds for changing clothes. This one near Bradley Point was gone by the 1950s, and only rotting pylons remained, jutting up from the water like a blackened comb.

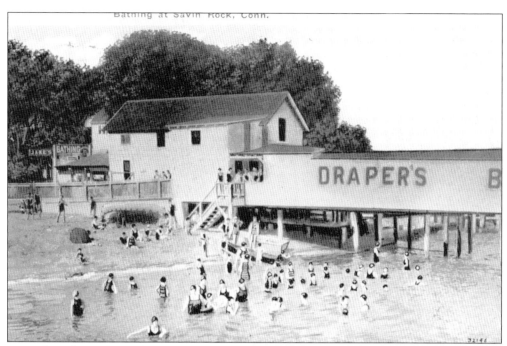

Bathing at Savin Rock, Conn.

Draper's Bathing Shed offered day visitors the opportunity to take advantage of the swimming without having to visit the park in wet suits.

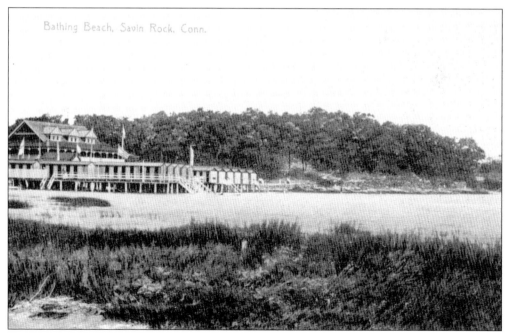

Bathing Beach, Savin Rock, Conn.

Bathing sheds and restaurants became a big business at Savin Rock. Modesty melted away as the 20th century began, and more women felt comfortable exposing more of their bodies to the sun and surf.

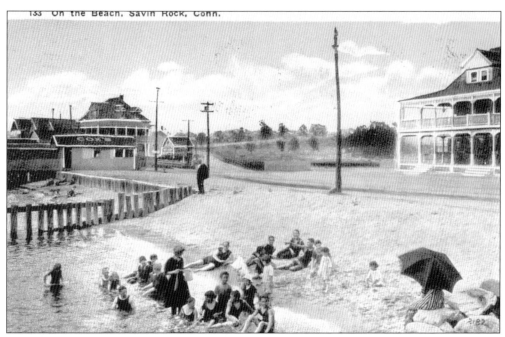

Hotels, like Cox's, adapted to the changing times and offered their own sheds for use. One advantage was that guests did not track as much sand into the hotel.

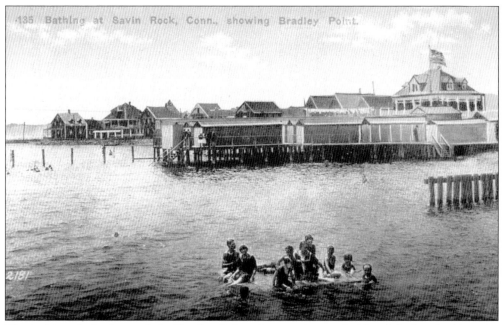

135 Bathing at Savin Rock, Conn., showing Bradley Point.

The bathing sheds cluttered the Bradley Point view on the north side of the beach. Here the average working man swam alongside the educated elite from Yale.

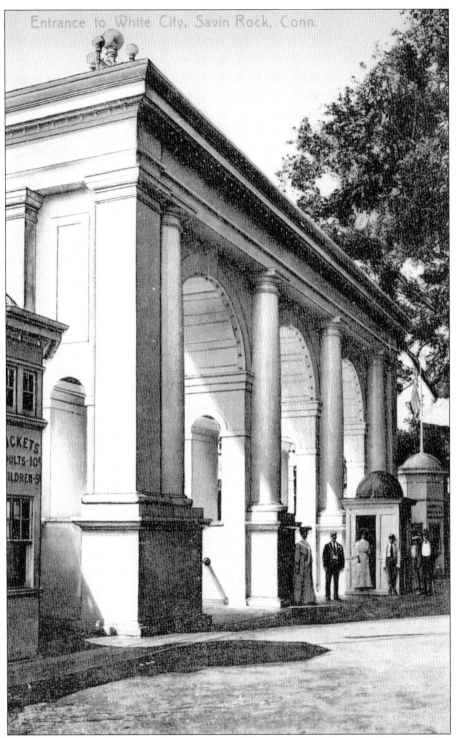

Mimicking the grand entrance to the Columbian Exposition's White City, this smaller Savin Rock version sported a similar portal. The neoclassical venue signified the park's glory days. It was a theme that was installed in amusement parks across the nation.

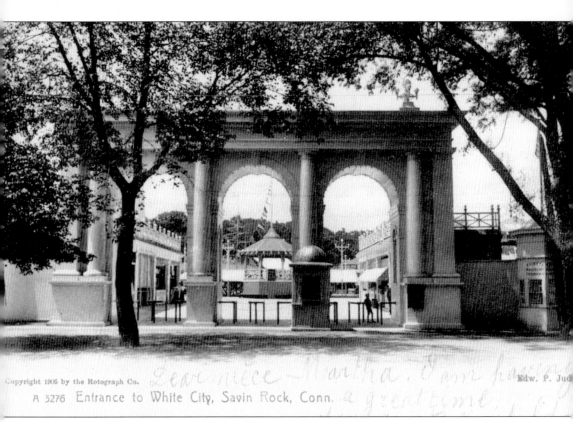

A 3276 Entrance to White City, Savin Rock, Conn.

Edw. P. Jud

The 1893 Columbian Exposition in Chicago was popular and reportedly drew over 300,000 people. This one in Savin Rock boasted 10,000 visitors.

Four

THE GOLDEN AGE

The golden age of Savin Rock coincided with the Gilded Age of the 1890s and continued to the close of World War I.

As beautiful a landscape and pastime that the grove provided, Americans continually yearned for bigger and brighter prospects. The next wave of Savin Rock entrepreneurs did not overlook the popularity of world's fairs and embarked upon a plan to make their site as entertaining.

The first project followed in the wake of the Chicago Columbian Exposition of 1893 where a "White City" was erected to house examples of technological improvements, exotic cultures, and a panorama of electric lights that continued the festive atmosphere long into the night.

Adjacent to the grove, a smaller version of that attraction was established at Savin Rock, complete with the classical pillared archway. In a much smaller area, nearly all the components of that attraction were erected around a placid, shallow pond that served as the splashdown for the hallmark ride Shoot the Chutes.

A miniature train traversed the White City, running past the amusement halls lining the edges. Boxing matches, vaudeville and burlesque shows, games of chance, and the like kept people entertained day and night. In time, motion pictures were added, and headliners like Jimmie Durante and Bob Hope were found on the marquees.

The most eye-catching component of the display was the electric tower bedecked with a plethora of colored lights that provided a night beacon seen for many miles. Other structures held an ice-skating rink that featured an annual two-mile race. Special events like a "deluge of fire" were designed to draw attention to the spectacle of flame.

Personal cars, both horse drawn and gas powered, began to fill the areas. Unused fields became makeshift parking lots for Henry Ford's latest models and even the newfangled motorcycles. Capitalizing on the swell of interest in the amusement park, restaurateurs erected elaborate dining facilities. One carriage after another dropped off wealthy factory owners, their families, Yale students and professors, and politicians along Beach Street where they could choose between Wilcox's and Bishop's Colonnade.

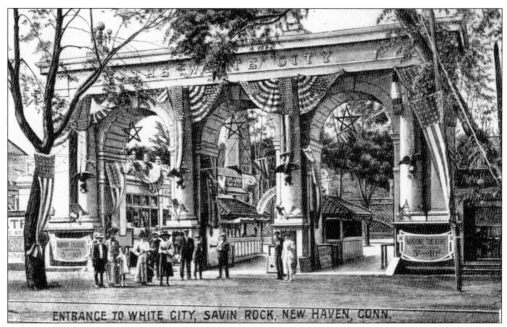

Savin Rock's patriotic displays had both benign and robust qualities. Whether it was a simple display of red, white, and blue bunting or a showy, glittering display of fireworks for the Fourth of July, the park encouraged nationalistic pride.

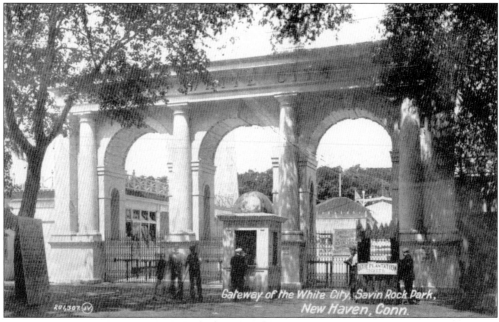

The White City established a level of construction that exceeded the simple sheds within the grove and created an environment that was more technologically appealing. At this point, Savin Rock portrayed both centuries—the more benign 19th-century park and grove and the 20th-century technology of White City.

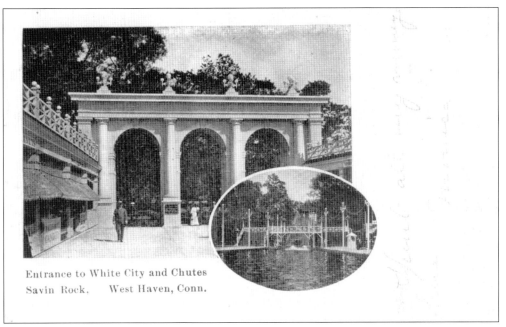

Entrance to White City and Chutes
Savin Rock. West Haven, Conn.

The White City had one major attraction ringed by buildings that housed attractions and souvenirs. The highlight was a mechanized ride and small electric lights that added to the hours of the park's operation.

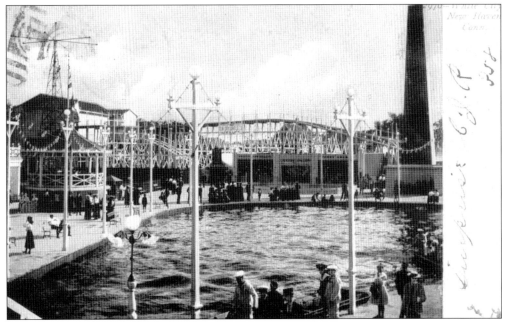

Along with the technological enhancements, other attractions were incorporated into this area. Bingo games and boxing matches added to the evening entertainment.

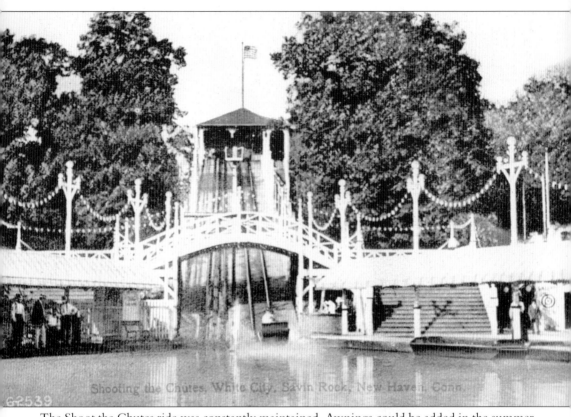

Shooting the Chutes, White City, Savin Rock, New Haven, Conn.

The Shoot the Chutes ride was constantly maintained. Awnings could be added in the summer months, and in the course of its life, the bridge was both straight across and arched.

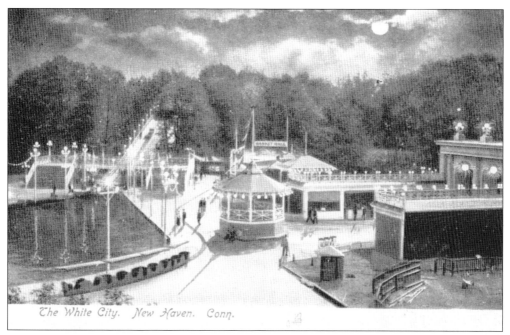

The White City. New Haven. Conn.

The addition of evening attractions boosted the revenue the park earned each season, creating a boon for the area. The possibilities of jobs brought in families that took advantage of the possibility of working a second-shift job close to home.

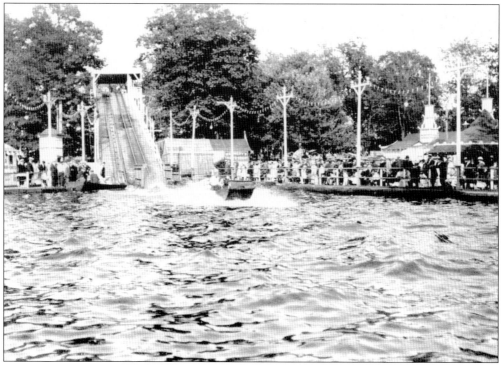

In the Shoot the Chutes ride at one end of the White City, a toboggan car with passengers slows from the drop by using the water of the central pond.

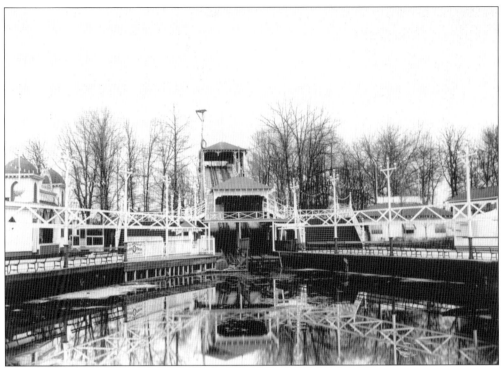

Winters in Connecticut last from November to May, and during that time, the park's rides remained closed. Souvenir sheds were sometimes kept open until Christmas, selling strings of colored lights, decorations, and toys.

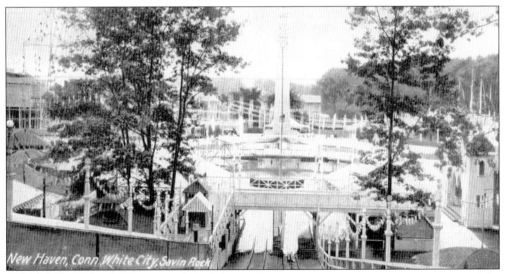

In time, a bridge crossed the splashdown point, allowing people to cross from one side of the pond to the other with greater ease. Savin Rock was a park that evolved, improving each section to meet the changing demands of the patrons.

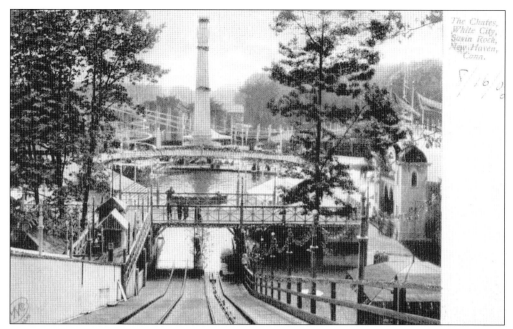

This was an age when gaslight was still in use. The electric tower and glittering outdoor lights proved electricity was a clean and easy utility to employ. This postcard is enhanced with glitter.

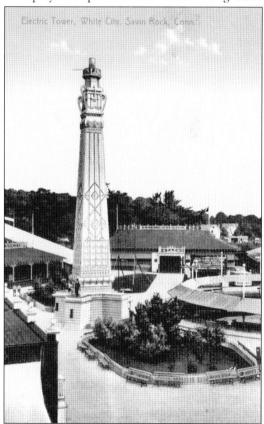

The electric tower at Savin Rock was patterned after the 300-foot construction at the Chicago Fair. More than 20,000 lights bedecked the structure. It was reported that the tower could be seen from higher elevations in other states. As with the Chicago tower, it became a beacon and meeting spot for park visitors.

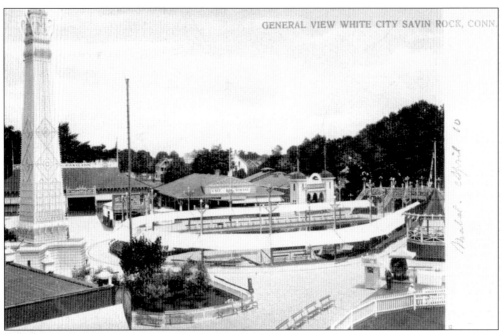

Overall, the White City was a self-contained unit within the larger park. The juxtaposition of the electric tower and the shady grove provided visitors with the best of both worlds.

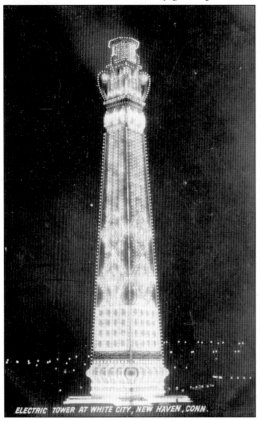

ELECTRIC TOWER AT WHITE CITY, NEW HAVEN, CONN.

The night design on the tower was elaborate and festive. As ships sailed into the harbor, they were greeted with a standard lighthouse on the east and a dazzling display to the west.

Come winter, the lights went out, and the park stood empty and dark. Each spring, however, heavy maintenance was required before the tourists poured through the gates.

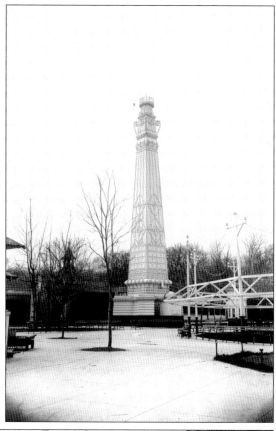

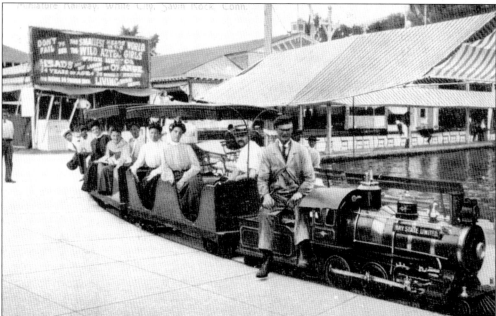

The miniature railway of White City was a copy of the one used in the Columbian Exposition of 1893.

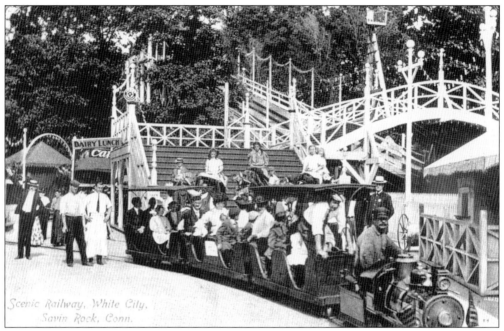

The ride was small enough for children to enjoy and offered a splendid ride around White City. The White City model was copied across America, with the one in Chicago operating into the Depression era. The miniature train was one of the signature ingredients.

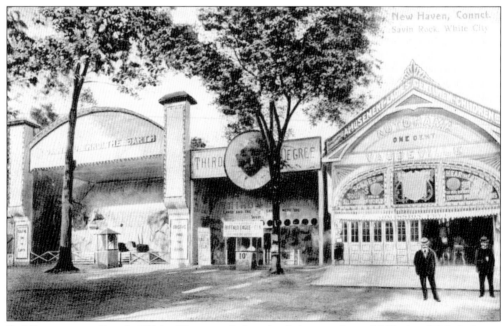

Buildings surrounding the White City were designed to bring a variety of titillation. Nickelodeons, scary displays, and trinkets abounded.

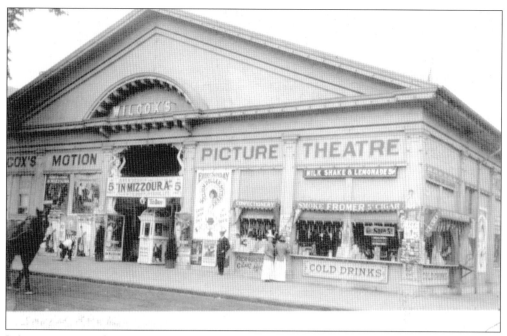

It is unsurprising that motion pictures were seen as novelty attractions, and even the outlying areas of Savin Rock Park sprouted theaters. This one was Frank Wilcox's, who maintained a restaurant, a carousel, and pier on Beach Street.

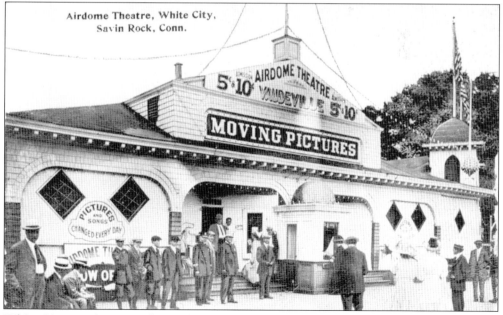

White City was the center for vaudeville. In the Airdome Theatre, live acts shared space with the moving pictures.

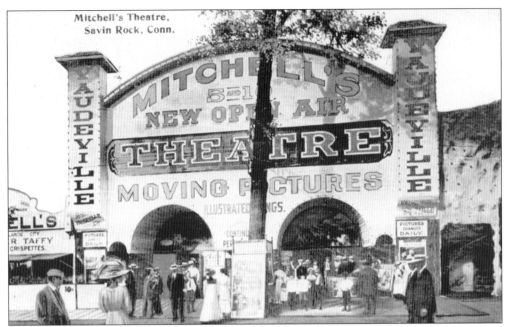

Mitchell's of White City was nestled between the volcano attraction and a food vendor. Because the moving pictures were "shorts," or nickelodeon style, enterprising theaters advertised a daily change of pictures.

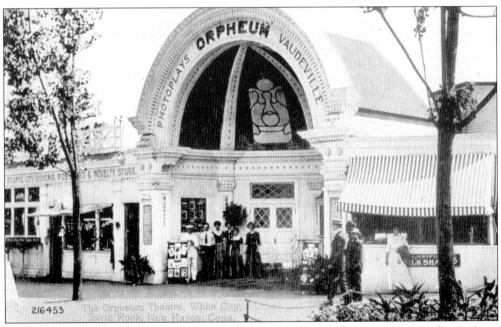

Vaudeville and photoplays graced the Orpheum in White City. The resplendent facade fit in well with the overall decor, but within the half-dome seems to be a more modernistic design. It was at this time that the famous Armory Show was taking place in New York City that featured the first of the cubist modernism.

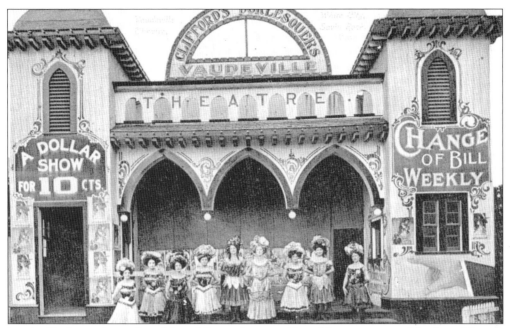

Vaudeville shows changed weekly and featured pretty girls and fancy costumes. The fancy Western dance hall–style costumes hearkened more toward the 19th century than the modern 20th.

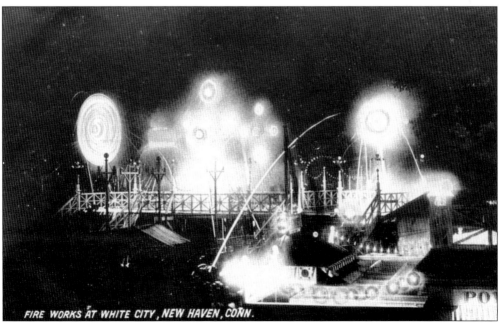

FIRE WORKS AT WHITE CITY, NEW HAVEN, CONN.

The White City panorama had a bit of everything. Electric lights, mechanized amusements, and even fireworks were all part of the draw. Savin Rock continues the legacy of summer fireworks each third of July when the local fire department puts on a dazzling display over the water.

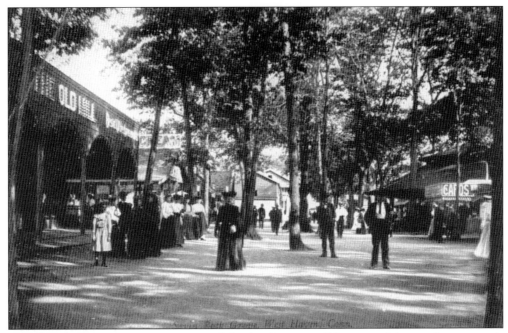

Competition for tourist money prompted the development of the grove. More and more stands were erected, and rides were added.

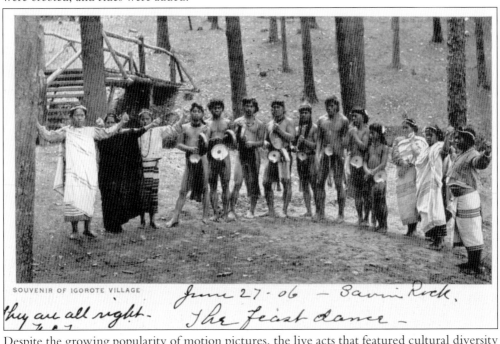

SOUVENIR OF IGOROTE VILLAGE June 27 · 06 — Savin Rock.
They are all right. The feast dance —

Despite the growing popularity of motion pictures, the live acts that featured cultural diversity drew a large crowd. The Igorote Village arrived in Savin Rock one summer following the St. Louis World's Fair. The featured attraction were native Philippinos of the Luzon Island known as headhunters. While in Savin Rock, as they had done in St. Louis, the group expected to practice their "dog feast," and one newspaper reported that while staying at the park, several neighborhood dogs went missing. In St. Louis, hundreds of dogs were supplied as food for the tribe.

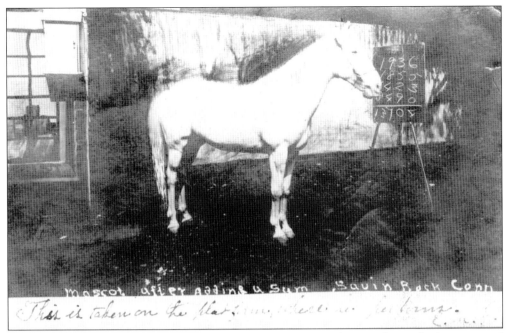

Mascot after adding a sum Savin Rock Conn

This is taken on the platform, where he turns.

Savin Rock appreciated the unusual, especially animal acts. This one featured a horse named Mascot doing sums with a chalk stick held between the lips. He was able to complete up to four sums.

The electric trolley replaced the horse-drawn ones introduced by Col. George Kelsey. The speed of the newer variety took a quarter of the time from the downtown green in New Haven to the White City turnaround in Savin Rock.

Visitors to the park looked forward to the open-air ride on the trolley. When the weather turned warm for the season, the sidewalls of the trolleys were removed.

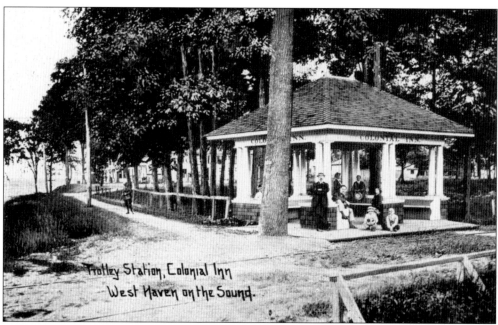

Trolley Station, Colonial Inn
West Haven on the Sound.

Trolley stations were set up along the park route. This one stood outside the Colonial Inn. The roofed booth protected the public from summer showers.

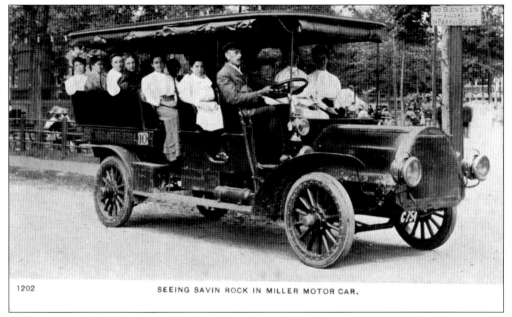

1202　　　　SEEING SAVIN ROCK IN MILLER MOTOR CAR.

Inside the park, Miller's Motor Car provided a faster way to see the sights. While the grove remained a haven for pedestrians, the touring car could navigate the entire perimeter of the park.

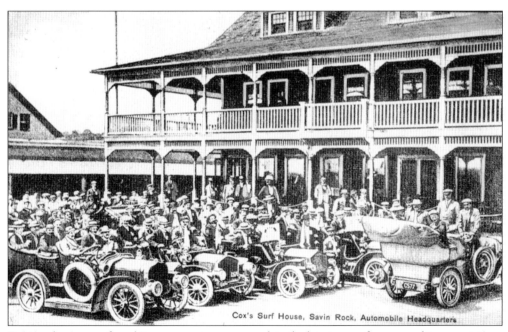

Cox's Surf House, Savin Rock, Automobile Headquarters

Existing businesses found it necessary to accommodate the latest craze for personal transportation. Cox's Surf House became an automobile headquarters in 1911.

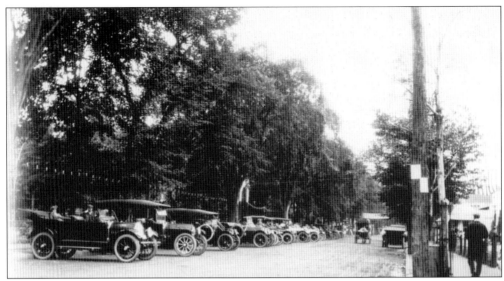

Streets lining the grove were wide and provided ample room for parking. In the beginning, the horseless carriages shared space with more traditional transportation.

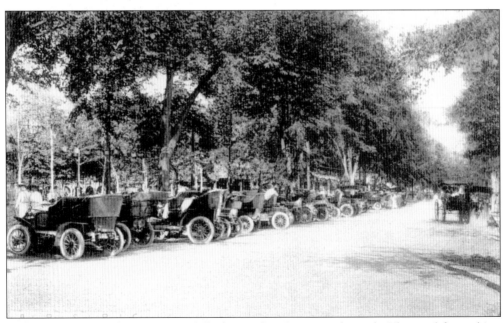

Each season more and more automobiles began showing up at the park. The need for parking space began to infringe on the space available for money-making attractions.

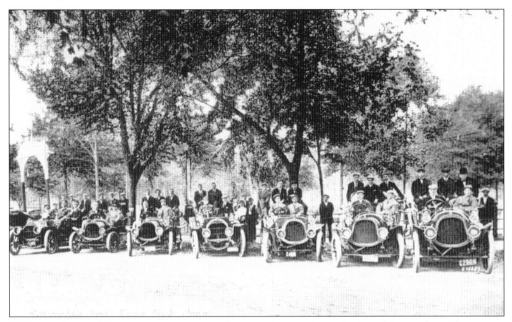

With the demand for attractions constantly straining the boundaries of the park, wider streets gave way to parallel parking. When this photograph was taken, the large avenues surrounding the grove provided ample space for both the car and horse-drawn carriages as well as trolleys.

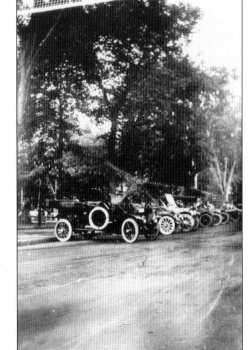

The introduction of the automobile to the park was the first indication that the venue would decline. Automobiles demand space for parking, and most of the land surrounding the area was marshy or built up with homes. A switch over from mass transit to private car meant fewer people could come to the park, and those having to park and walk a great distance began their day or evening with aggravation.

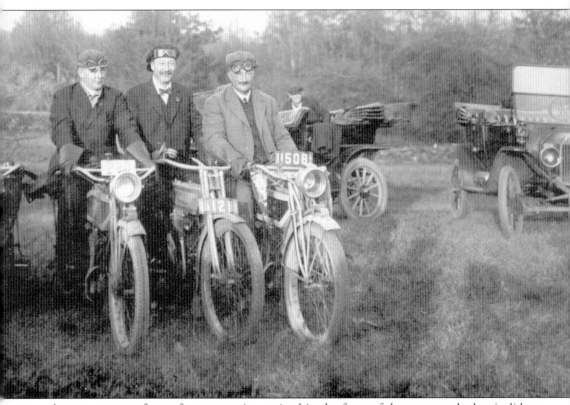

A more compact form of transportation arrived in the form of the motorcycle, but it did not supplant the practicality of the automobile. Motorcycles did, however, become a racing attraction. These gentlemen appear more attired for dinner than racing.

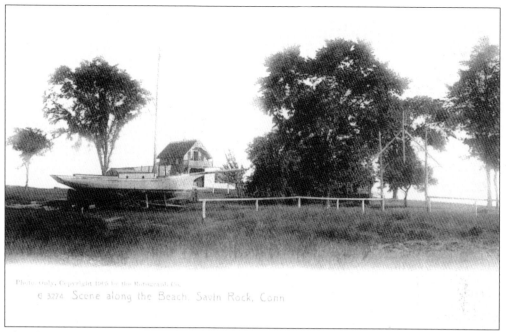

This close-up of the card on page 8 shows the initial style of homestead. Many of the families chose to live on the West Shore because it was a beach-loving community. Sailboats like this provided pleasant pastimes because both the harbor and Long Island Sound are calm waters.

With seafood available for the taking, even renters could augment their income with food stalls. The harbor was rife with a multitude of fish like stripers, bass, blues, flounder, and eel.

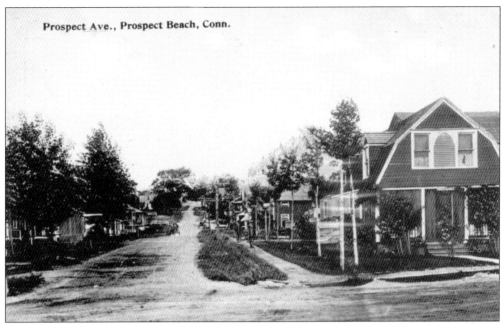

Prospect Ave., Prospect Beach, Conn.

As the area prospered, neighborhoods along the shore grew more densely packed. Hillside bungalows on Prospect Avenue were typical of the beach neighborhood a few blocks from Savin Rock. From the sandy beach along Ocean Avenue, the street rose to a level plain where Highland Avenue intersected. At the very top of Prospect Avenue was a town park where children could play.

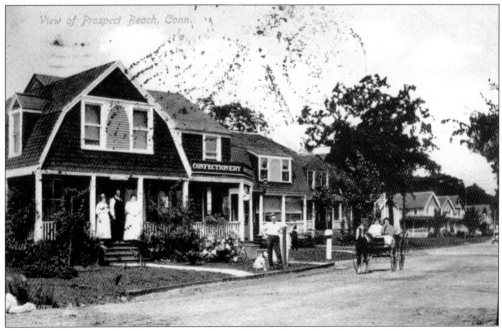

View of Prospect Beach, Conn.

CONFECTIONERY

This same house, at a different angle, shows that at-home businesses took advantage of their location. This particular corner house gave way to the West Shore Pharmacy in later years.

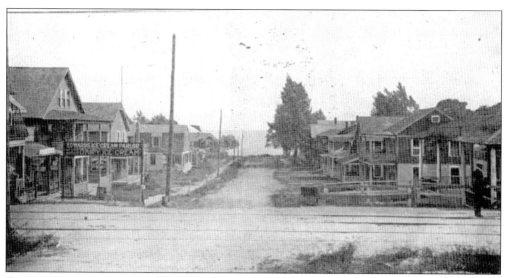

Prospect Avenue was a part of the bungalow community of homes erected on the hillside leading up from Ocean Avenue just south of the park. This view is taken midway where the trolley line ran. Today the street is wider and paved, and trees line the sidewalks. The trolley rails are covered, and only a portion of the line remains open and unused. At the time of Savin Rock's demise in 1966, little had changed in this neighborhood. The home at the extreme right was replaced by Jack's Variety, and to the left, the ice-cream parlor housed a branch location for the West Haven Public Library. But it was from neighborhoods like these that teenagers were culled as summer help at the rock.

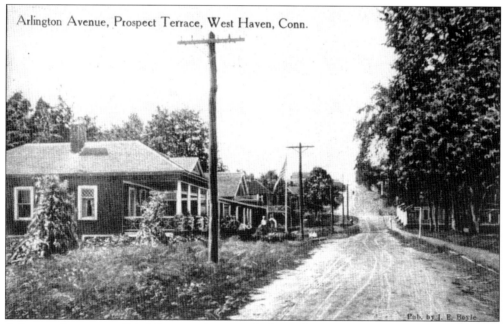

Arlington Avenue paralleled Prospect Avenue. The bungalows constructed up the hillside streets like Ivy, Grove, Sea Bluff, and Dawson were typical, inexpensive cottage models.

Prospect Beach stretched along the south side of the rock. This portion at the base of Fairview Avenue offered summer fun for the local children. The amusement park was a short walk from here.

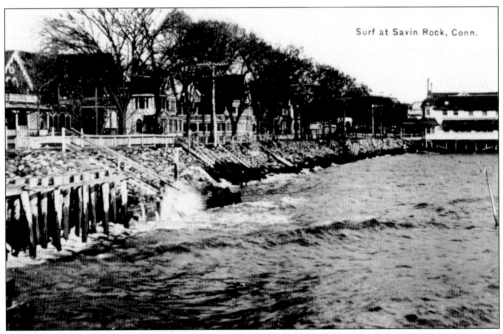

On the park side of Savin Rock, the shore was not sandy, and homes along Beach Street faced a seawall.

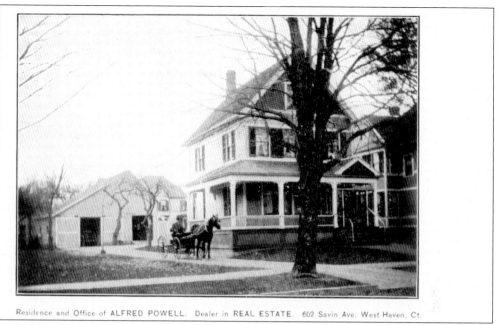

Residence and Office of ALFRED POWELL. Dealer in REAL ESTATE. 602 Savin Ave, West Haven, Ct.

This large home on Savin Avenue was near the park and owned by a realtor. The neighborhoods like this were older and the houses larger. In time, homes like this replaced the large barn out back with a smaller car garage.

Others, like Cherry Cottage on Forest Road, were large enough to house guests. Spare bedrooms provided a steady summer income, letting the house pay for itself.

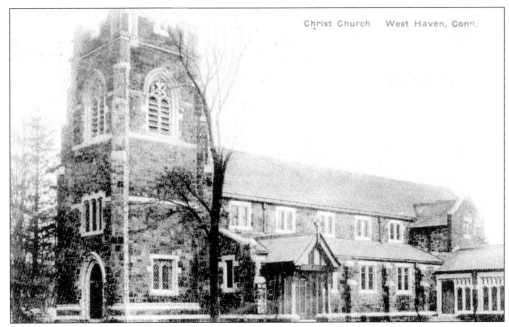

The prosperity of the area replaced the old Colonial clapboard buildings with more elegant stone structures. West Haven was quickly developing its own entity and soon pulled away from New Haven, Milford, and Orange.

This stately stone house of worship was a stark contrast to the glitter and transitory nature of the park nearby. The quality and stability of this church demonstrates a stable and prosperous community.

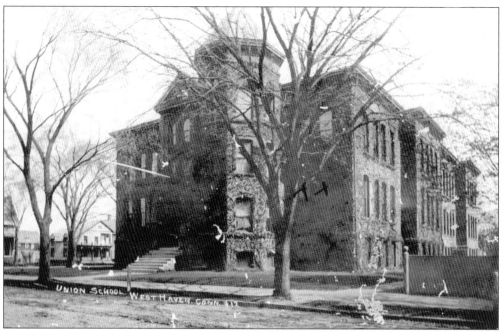

Union School was built to accommodate the burgeoning local population. The park's prosperity brought with it a greater demand on the community's infrastructure, increasing the need for social services, schools, and public works.

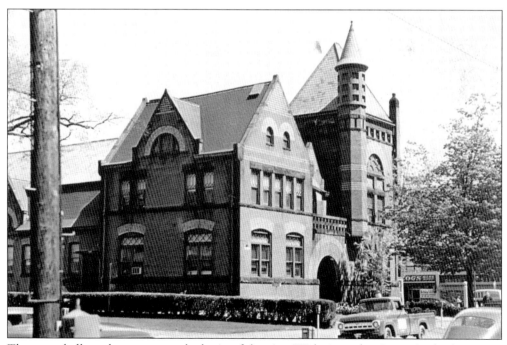

The town hall on the green was the heart of the city. With time, the city enticed other, more substantial businesses. Like communities across America, West Haven faced the problems associated with growth.

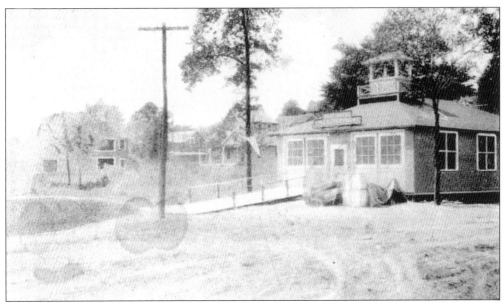

The growing town and successful tourist venue placed demands upon the city for services. The West Shore Fire Department began humbly enough near Dawson Avenue.

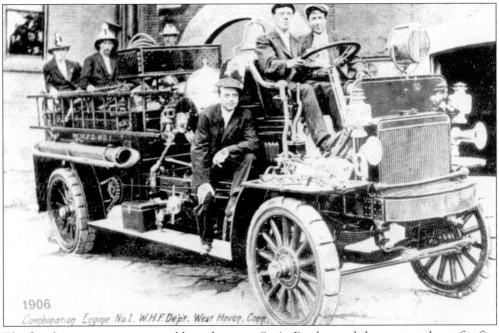

1906
Combination Engine No.1. W.H.F. Dept. West Haven, Conn.

The fire department was manned by volunteers. Savin Rock posed the greatest threat for fire because of the large crowds, flimsy buildings, and heavy use of electricity outdoors.

The library in the town center provided a seat for learning that was free to the families who worked at the park. For the number of immigrant workers, this was often their first encounter with American learning. In time, a branch was erected on Prospect Avenue on the other side of the park.

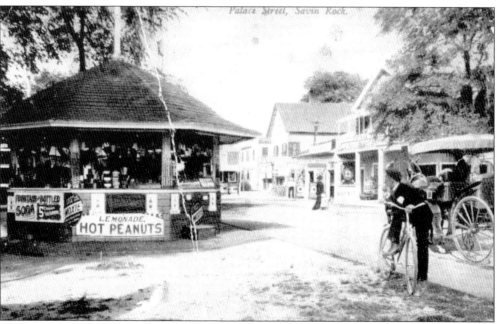

Almost every street within the Savin Rock area began sporting souvenir and food stalls. Streets were crowded with people, horses, cars, and bicycles. The area was alive with smells of hot sumptuous food, noise filled the summer air, and everywhere one looked there was color and activity.

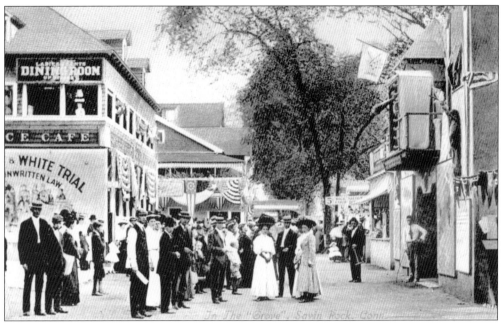

The demand for more attractions cut into the open space of the grove. The earlier rustic sheds dotting the area gave way to larger two-story structures. The midway was a street right out of a fairy tale.

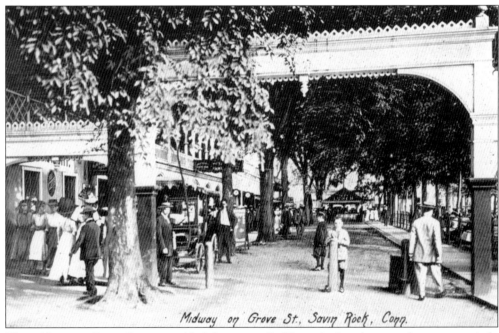

The midway on Grove Street provided the most relief from the heat because the owners wisely left the shade trees standing.

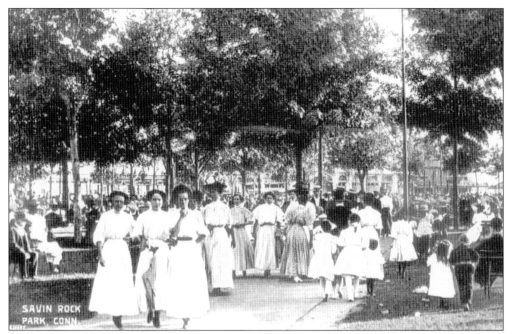

The beginning of the 20th century was a time of prosperity. Savin Rock provided ample transportation to and from the area. The hotels were aplenty. Crowds like this were seen nearly every day for three months of the year.

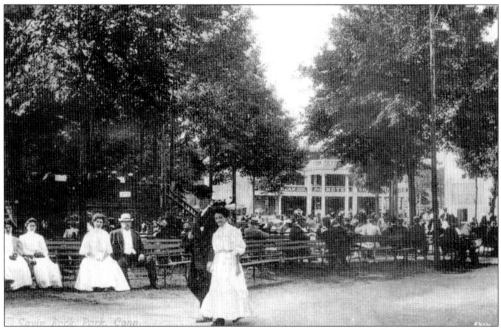

At the height of its glory, the crowds gathered at Savin Rock came attired in their summer best. With temperatures reaching into the 80s and 90s at the peak of summer, the long dresses and starched suits provided little relief.

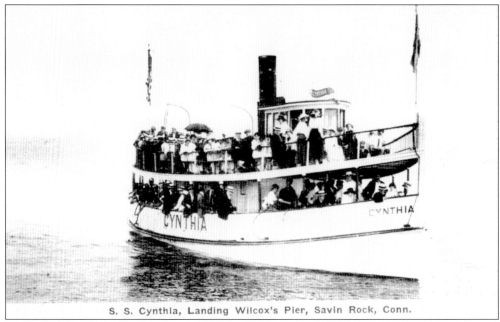

S. S. Cynthia, Landing Wilcox's Pier, Savin Rock, Conn.

Col. George Kelsey's ferry proved so popular and effective that other services began to ply the water. Two of the most remembered are the *Cynthia* and the *Zephyr*. Regular docking schedules were maintained.

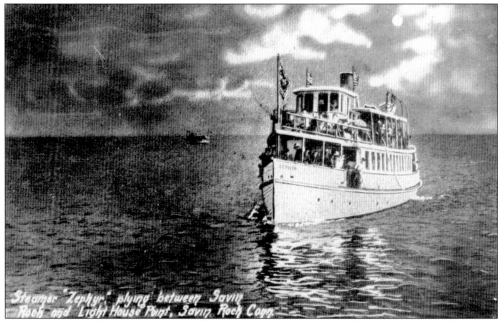

Steamer "Zephyr" plying between Savin Rock and Light House Point, Savin Rock Conn.

The ferries ran day and night, and the colorful lights playing across the dark waters seemed like shimmering jewels.

Five

DINING ON THE SHORE

Dining became another facet of the growth in Savin Rock. With fresh seafood plentiful outside their doors, restaurants like Wilcox's sprouted up along Beach Street. On only a miniscule spit of land, both Wilcox's and the Colonnade stretched out over the water, resting on a grid of pylons and providing an elegant and ample dining area within.

Oysters on the half shell, lobster, crab, fresh fish, and clams lined the menu, and Wilcox's boasted of having the largest selection of seafood in southern New England.

This restaurant ensured its success by constructing a similar pier next to the restaurant that was long and contained both a domed ice-cream stand and small souvenir shacks along the route. Those coming in off the ferry found Wilcox's closest at hand.

The draw of people to piers led to the construction of others. Capt. Al Widmann commissioned two, each opposite the other, in 1901 and began a cross-harbor race between Savin Rock and Lighthouse Point. Contestants were charged a $2 fee that was returned when they reached the opposite shore. The race continued as a summer event until 1934 when the weight of spectators collapsed the Lighthouse Point pier into the water.

A steady surge of people arriving at Savin Rock throughout the summer spawned its own second-tier string of eateries that were more affordable even if they were less glamorous. From the simplicity of TRYUS, where a front porch turned into a fast-food stand, to more spacious sit-down restaurants, food sales provided local owners with healthy incomes.

Restaurant growth continued past the Second World War, establishing a mix of hot dog stand with indoor dining capabilities. One of the most enduring was Jimmies. Owned by the Gagliardi family, Jimmies began as a fast-food stand on the lee side of Savin Rock. Fast food aptly applied to this outdoor stand as hot dogs were split, grilled, and bunned in a matter of minutes. Succulent lobster rolls and seemingly more clam dishes than shrimp in *Forrest Gump* were served to Americans on the move.

Nearby, on a summer evening, crowds gathered to watch the stock car races, and many of those attending could be counted on to stop by for a quick snack of lobster roll or fried clams. Phyllis', Turk's, Apps, Rafaelli's, and other eateries lined the narrow streets, each competing by finding some significant way of beckoning customers to their tables.

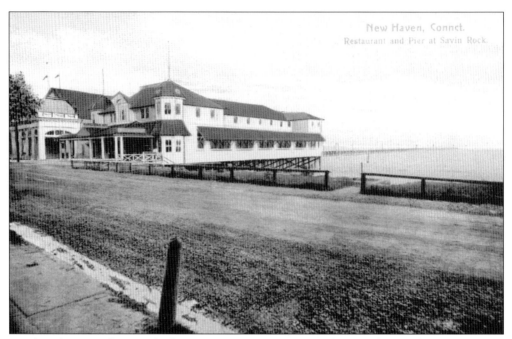

Frank Wilcox saved money by buying a narrow strip on Beach Street but used an enterprising way of maximizing its investment. The dining room was built on pylons and jutted out over the water.

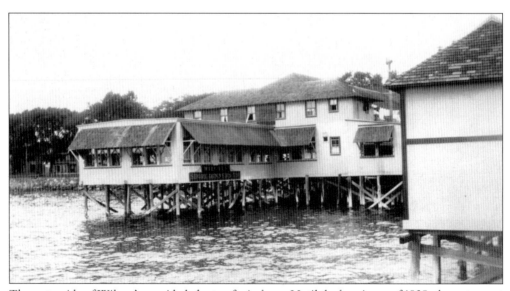

The water side of Wilcox's provided plenty of windows. Until the hurricane of 1938, the restaurant faced little danger from the calm harbor waters.

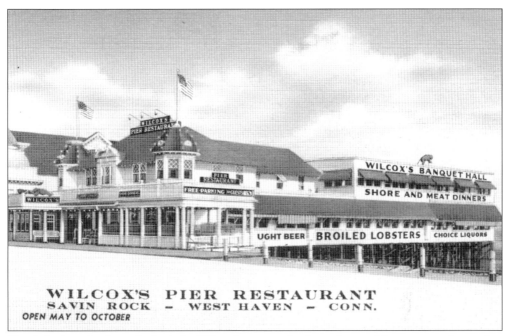

Good, fresh seafood was the basis for Wilcox's success. As the park passed from a genteel watering spot to one of a more plebeian nature, Wilcox's began sporting painted signs advertising its menu. It was one business in Savin Rock that changed according to the public's tastes.

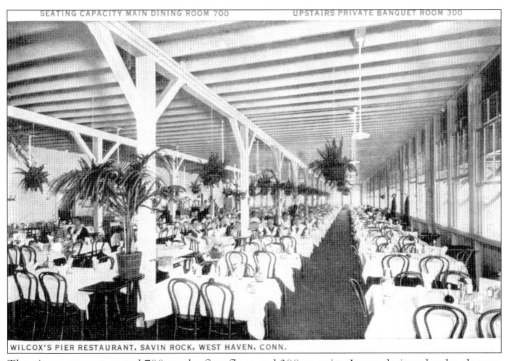

The pier restaurant seated 700 on the first floor and 300 upstairs. It was designed to be elegant, with every table linen-clad and a fully uniformed waitstaff. In time, Wilcox's hosted dance marathons, comedians, and live music.

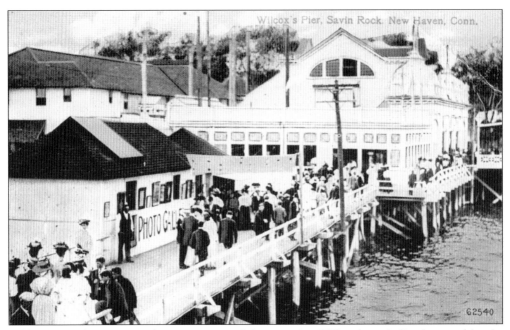

Adding a pavilion next to the restaurant and, later, a pier, Wilcox's capitalized on making its spot the foremost attraction on Beach Street. Its success spurred competition.

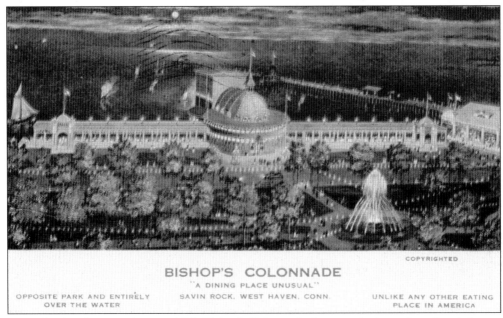

One of Wilcox's competitors was Yale Bishop's Colonnade that stretched out along Beach Street. It was a massive, elegant structure resplendently symbolizing the Gilded Age of America.

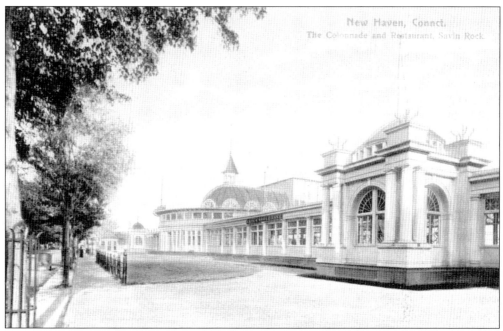

The long wings were sometimes enclosed with glass to create large dining halls. The central feature of the restaurant was the open-air kitchen toward the rear of the center entrance.

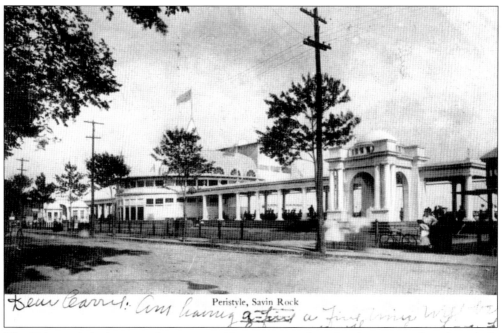

The Colonnade had a central structure with two open wings fanning out north and south. It opened in 1904 and lasted until 1921 when a fire razed the entire building.

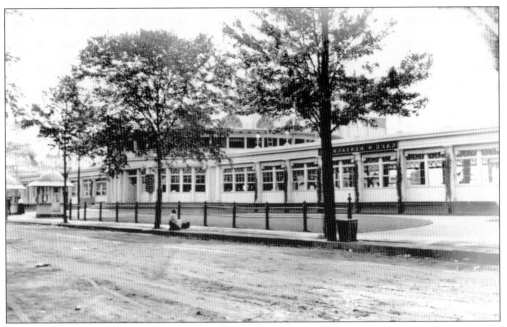

The restaurant could seat 1,000 and was a favorite site for Yale reunions. Centrally located at Savin Rock, the restaurant was hugely successful, and a steady stream of people disembarked from carriages and cars at a regular pace.

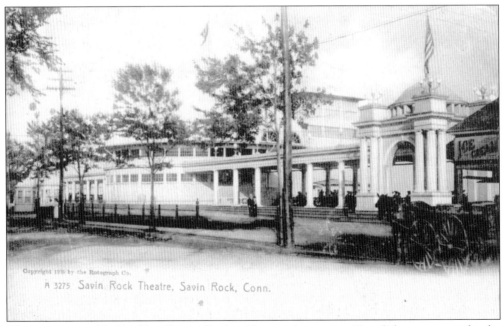

A 3275 Savin Rock Theatre, Savin Rock, Conn.

The restaurant prided itself on fine seafood and innovative menus. One dish was reported to be crabmeat Tokyo, which was crab cooked in a small bean pot and covered in a sauce concoction of tomato and pea soup.

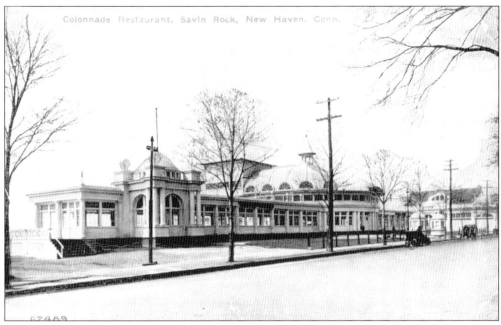

The building was 360 feet long, and its open-air construction provided a sunny environment and took advantage of the sea breeze. Seeing the success of the local piers, the Colonnade aped Wilcox's and constructed one of its own. With that in place, "Yalies" could travel from their yacht club farther up the harbor and dock behind the restaurant.

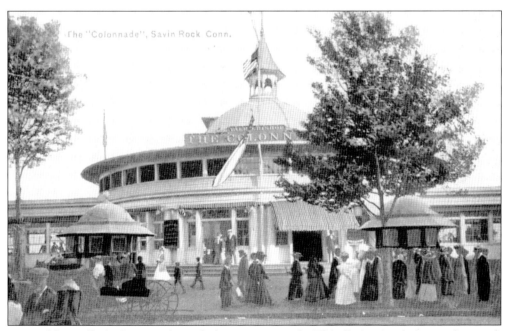

Most of the traffic had to pass through the center rotunda. This distinctive design made a mark of excellence in the park.

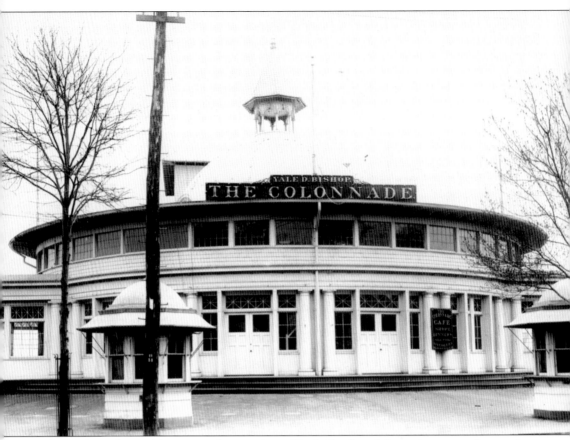

The Colonnade was like every other portion of Savin Rock and dependent upon the weather. Having been constructed over water, it was cold and damp in winter. Traveling along Beach Street in the off-season could be depressing. Whitewashed buildings grew grimy with soot and mold, windows dusted over.

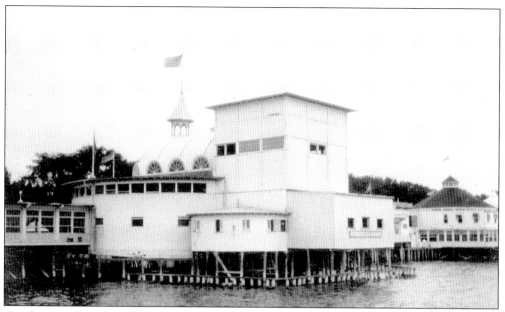

On the sea side, a boxlike structure posed a more utilitarian face and was enclosed against the weather.

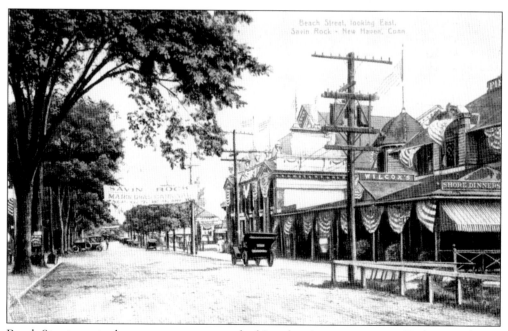

Beach Street was truly a restaurant row overlooking the picturesque grove. Each season began with Decoration Day, and in Savin Rock, they lived up to that name.

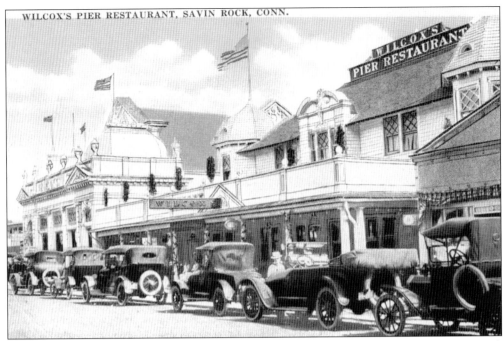

On Beach Street, Wilcox's was the more enduring venue. Using its profits to continually expand, the restaurant added a pavilion and pier, dominating the south side of Beach Street well into the 20th century.

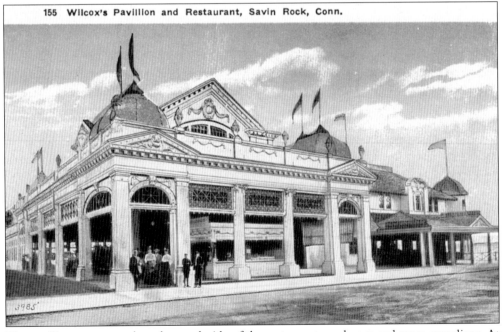

155 Wilcox's Pavillion and Restaurant, Savin Rock, Conn.

The pavilion constructed on the north side of the restaurant was larger and more grandiose. At the time of its construction Beach Street was still a dirt road, and lawn could be seen along the route. By the time of its demise, Wilcox's was dwarfed by other, more modern attractions.

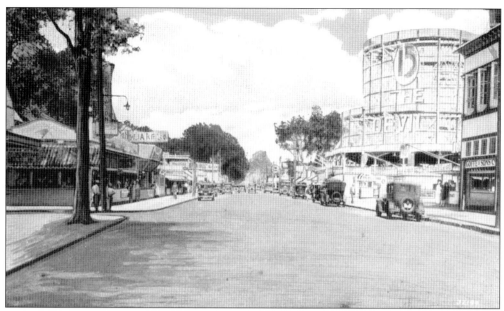

Beach Street, like Wilcox's, changed over time. The elegant structures gave way to smaller buildings, and the beach side became peppered with piers and roller coasters.

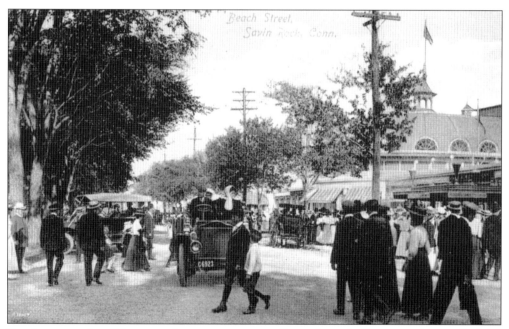

For three months of the year, there was a nonstop flow of people from morning until night. This meant that property values rose steadily and generated greater growth. More concessions meant more job opportunities, and Savin Rock provided work experience for many West Haven teenagers. Beach Street concessions offered plenty of opportunities.

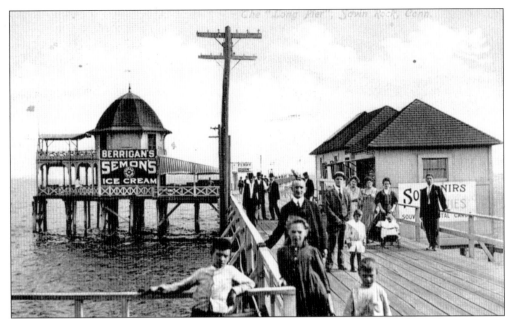

Large piers were a way of extending the sales route out over the water, leading out from and into Beach Street. Wilcox's was the most sophisticated. Those disembarking at the ferry slip walked past a two-story ice-cream parlor and souvenir stands getting into the park. These small sheds later provided one last chance for sales before the park visitors left for home.

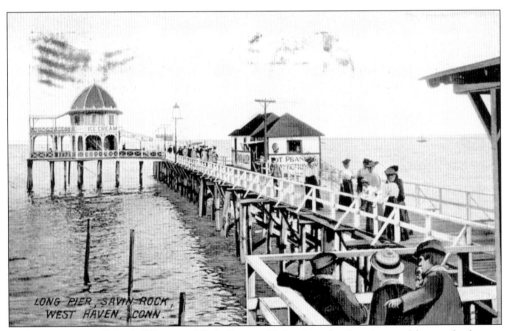

Wilcox recognized the brilliance of Col. George Kelsey's early planning and knew the key to success was to be the first and last stop at the park. Throughout the day and evening, ferries docked with regularity, and the traffic on the wooden walk was ceaseless.

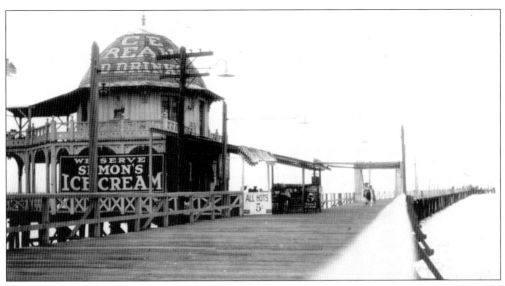

The pier gave Wilcox's the opportunity to provide quick, inexpensive food to people who could not afford to sit in its elegant dining room. Outside, on the way to the ferry, people could sit out of doors eating All Hots (hot dogs) and ice cream.

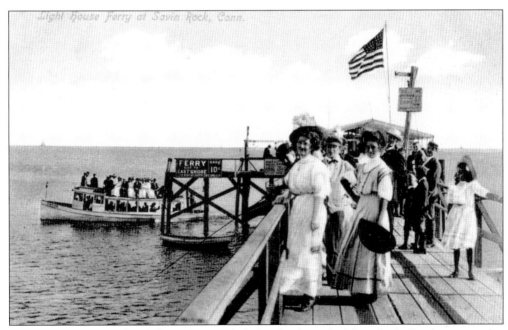

The women, too, outfitted themselves in their Sunday best. A visit to Savin Rock meant a day spent away from "normal" life, most likely meeting people one knew in a more congenial setting. Most people one passed on the street, in line, or at the dock were wearing happy grins.

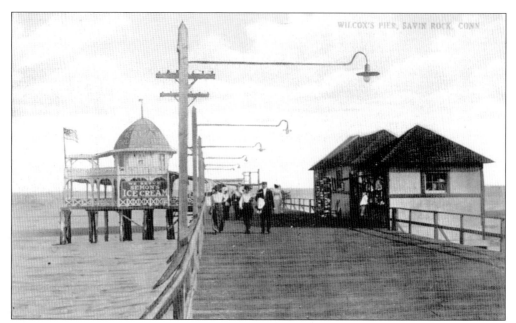

As long as there was sunshine, there were customers. The weather at the shore is temperate, but late July into mid-August, there were dog days where the oppressive heat was only relieved by thunderstorms. But a spell of sustained rain could keep the piers and Beach Street empty.

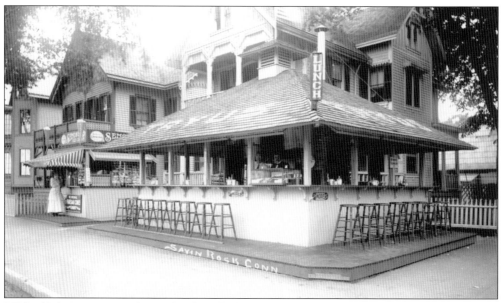

With a little ingenuity and some hard work, local homes were transformed into money-making properties. Places like TRYUS were little more than extensions of a front porch with stools lining the counter. Crowds visiting the rock could keep a place like this busy from 11:00 a.m. until 11:00 p.m., earning a handsome summer income.

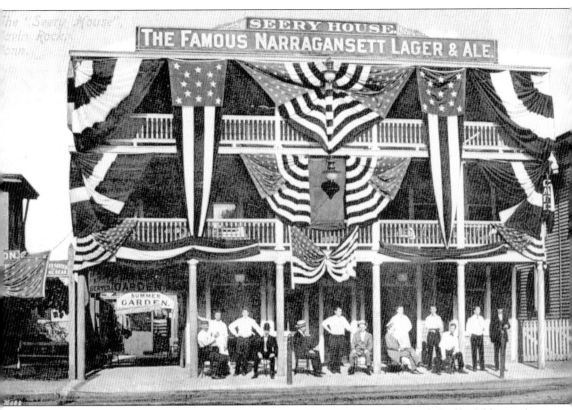

Among the second tier of restaurants, places like the Seery House provided affordable meals and drinks.

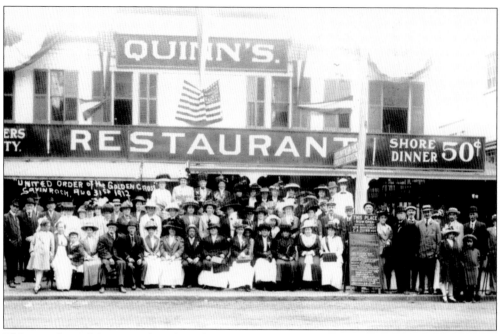

This meeting of the United Order of the Golden Cross visited Quinn's in 1912. Attracting groups meant a full dining room.

Whether they were Yale students, fraternal organizations, or work outings, Savin Rock provided plenty of places for people to meet and mingle. Outings like this were special to the participants and often eagerly anticipated. It was certainly considered a dress up affair.

Six

THE FLYING HORSES

Rides had been a staple of Savin Rock from the earliest times and carousels featured foremost among them, though the earliest were horse powered. One of the first to grace the grove was a small model turned by a memorable tobacco-chewing chestnut pony. In time, the real ponies gave way to combustible horsepower, and the age of the flying horses began.

No mechanized amusement touched the memories of Savin Rock patrons as did the wonderful array of carousels sported throughout the park. A good part of this is fueled by the fact that two locals, the Murphy brothers (who owned Murphy's Niklet), were among the finest carousel creators America has ever known.

Their work began in 1895 with the construction of carved horses, gilded chariots, and other fabulous creatures affixed in a stationary or moveable manner to a whirling platform propelled by belt and motor and was completed with a loud, cacophonous calliope of music. Charles I. A. Loof and Charles Carmel were the master carvers who were responsible for the intricacies and beauty of the pieces.

Other carousels became the staple of amusement for Savin Rock, and established businesses were soon incorporating them into their attractions. Wilcox's erected a pavilion next to the restaurant to house its carousel. A magnificent carousel house was installed within the park interior. But no carousel was as favored by the locals as that sitting near to Liberty Pier. The Flying Horses of Beach Street was a 1912 installation that operated every season until Savin Rock's demise in 1966. From there, this carousel was moved to Magic Mountain in California where tourists can experience the thrill of a bygone era.

Flying horses, as they were known at Savin Rock, were gaudy, thrilling rides complete with traditional brass rings that, when grabbed, provided a free turn. The intricate carvings and expensive mechanization demanded shelter, and barnlike structures with open fronts enabled visitors to remain at the park no matter the weather. The exterior walls were often lined with arcade games and benches for waiting family members.

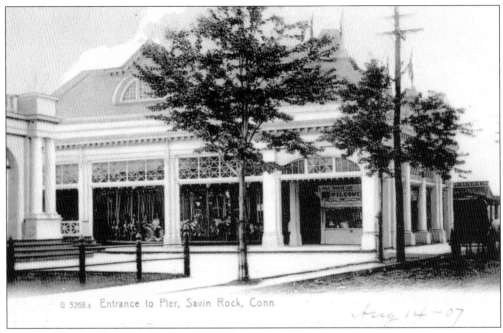

Between the pavilion and Colonnade was the entrance to Wilcox's pier. Within the pavilion, nearly all the space was relegated to the carousel.

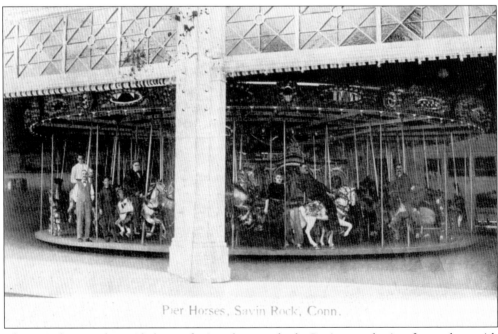

The typical carousel provided a seat for just about anybody. Stationary chariots for mothers with babes or the elderly, nonmoving horses for the toddlers, and mechanized steeds that rose and fell provided entertainment for just about everybody else.

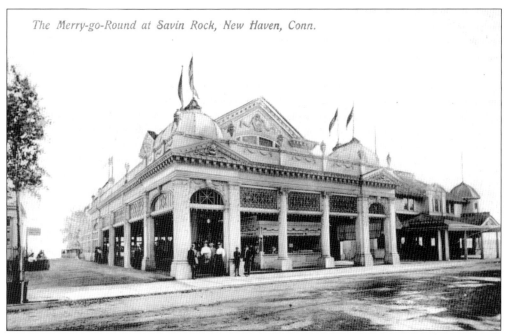

Wilcox's Restaurant on Beach Street erected an elaborate pavilion to house its carousel. The expensive carvings and mechanical engine needed protection from the elements.

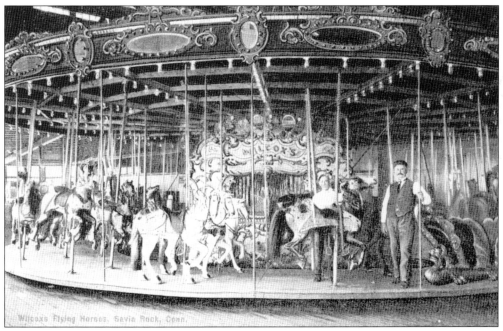

With so many carousels operating at once, the race was on to draw customers. Using the adage "everybody loves a crowd," carousel operators encouraged people to ride multiple times. To promote this, brass rings hung near the carousel. Getting one meant a free turn.

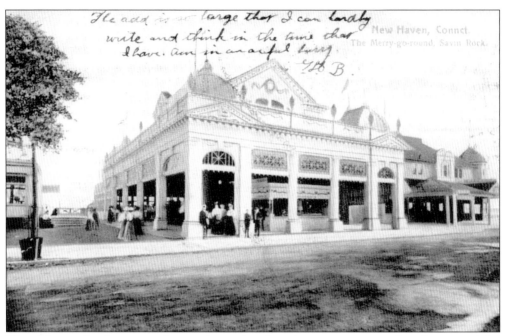

The elaborate facade was a tad more decorative than the restaurant next door but provided a nice segue to the Colonnade on the opposite side.

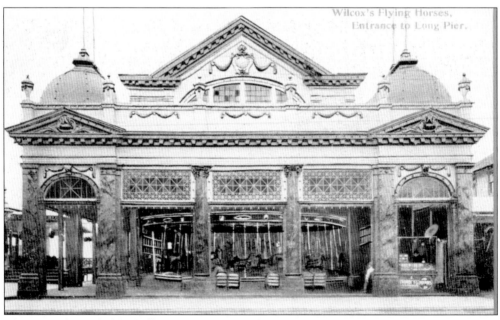

The oriental motif of the building contained many windows that let in light. The pavilion itself was a shell of wood with large openings at the street. Small concessions often lined the inner walls, and benches were made available to parents waiting while their children rode.

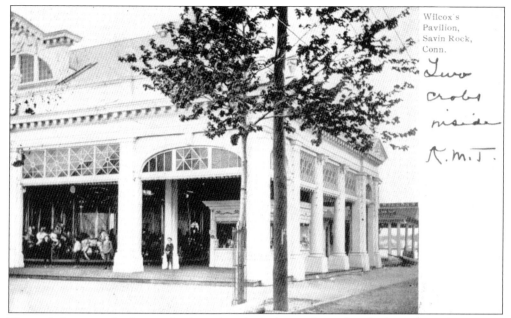

Through these portals, thousands of people rode the horses day and night throughout the summer months. The heat from the engine turning the carousel benefited by the breeze outside that was allowed in by the large openings.

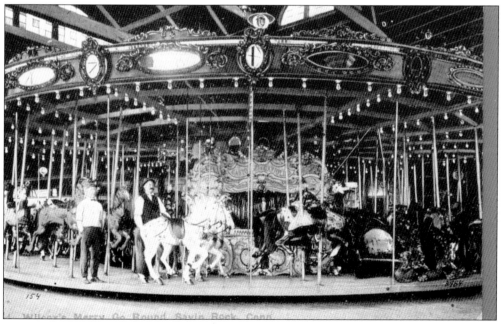

In the center was the organ that played preprogrammed music. The top was bedecked with a panorama of scenes, mirrors, gilt frames, and electric lights.

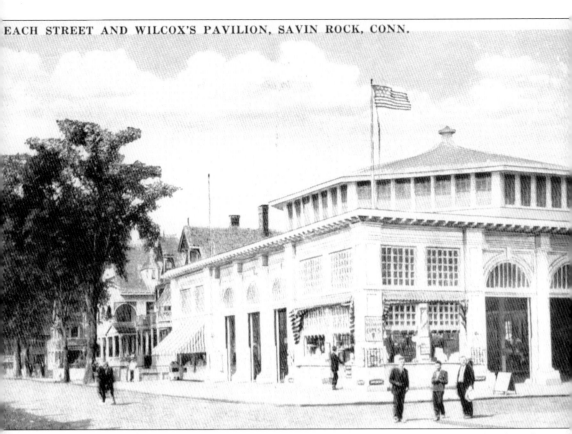

Even the outer corners of the pavilion were valuable property and utilized for food kiosks. The easy access to snacks was one way to keep customers nearby.

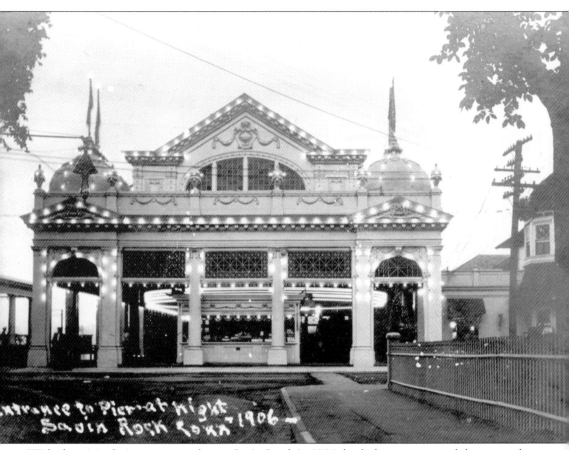

With electricity being commonplace at Savin Rock in 1906, both the structure and the carousel could be lit at night.

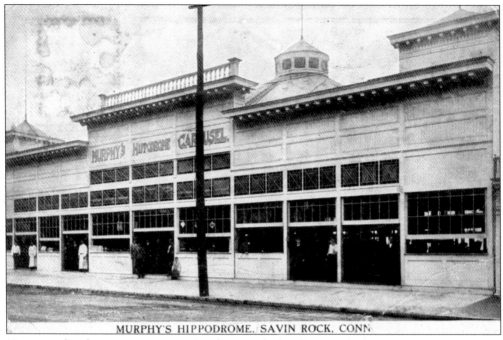

MURPHY'S HIPPODROME, SAVIN ROCK, CONN.

No carousel makers were as respected as the Murphy brothers. Aside from building flying horses for others, the brothers maintained their own concession at the park.

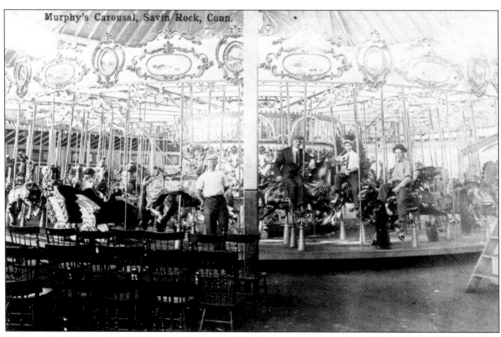

Murphy's Carousal, Savin Rock, Conn.

The mechanism was belt driven, and a snapped leather strap meant a loss of income and disgruntled customers. The Murphys' reputation was one of reliability and craftsmanship—both in wood and with steel.

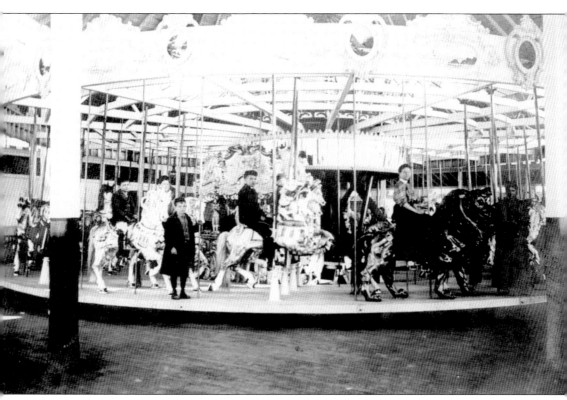

The Murphy carousel contained more than 40 carved figures. Their specialty was the reliable mechanism operating the ride. The carousel had to be constructed to provide a smooth ride, with several actions taking place at once. The bed spins, the components go up and down, and music plays.

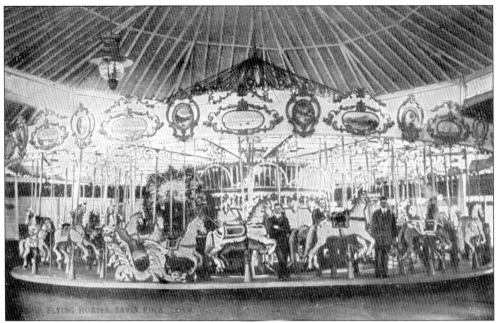

The noise from the calliope was loud and raucous, making polite conversation impossible. One of the thrills of the ride was having to shout to other passengers over the din. The whirling lights and smells of cotton candy and other park foods made the experience dazzling.

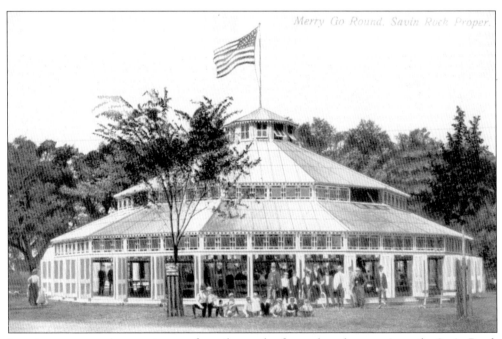

In a more open environment, away from the crush of crowds and concessions, the Savin Rock carousel was constructed in the round. The windows on top ventilated the space and provided an exit for the heat generated by the carousel engine.

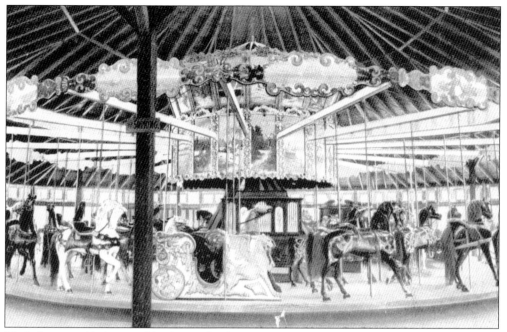

Mythology provided some of the designs for chariots. This one with a winged griffin pulling a chariot looked like it came straight from Mesopotamia. Horses were decked out in medieval raiment.

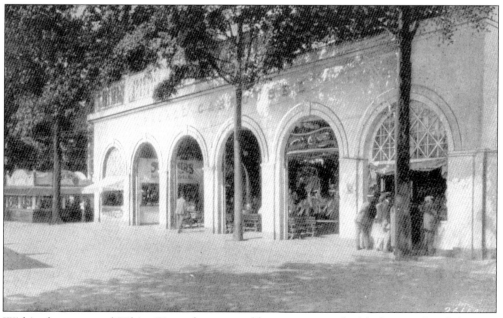

Within the grove and White City, other carousel houses competed with those on Beach Street

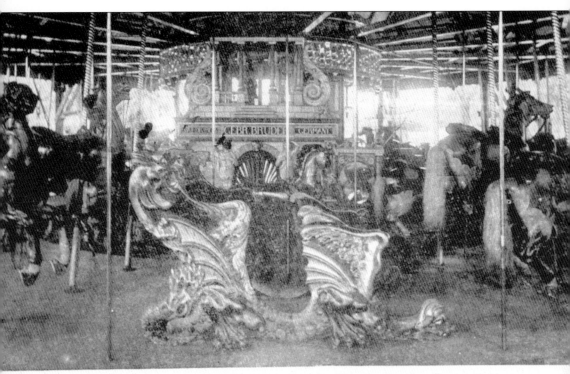

Flying Horses in Railroad Grove, Savin Rock, Conn.

Imaginations were put to the test when the carvings were designed. Horses could be equipped with real horsehair tails; stationary chariots could be as elaborate as this scaly dragon.

Seven

MECHANIZED RIDES

Rides proved to be an invaluable source of revenue for the park. From the time of its golden age, large, noisy machines in bright, glossy colors added squeals of delight to the sounds in the park. But the majority of the larger rides made their way into the park in the mid-1920s, beckoning customers with electric signs.

Savin Rock provided all of the amusement staples, very expensive and mechanically complex, and these provided visitors with choices for amusement—rides based on darkness and painted dioramas or others based on speed. From simple canal rides to zooming roller coasters, Savin Rock provided a complete array of delights found in other amusement parks across the nation.

Other than roller coasters, the majority of the big rides arrived in 1925 when the Jitterbug, the Virginia Reel, the Seaplane Swing, and the Mill Chutes were introduced. The Jitterbug and Virginia Reel were maintained as attractions until urban renewal began, the Virginia Reel being the first to be demolished.

Soon fun houses cropped up throughout the park. Noah's Ark was one of the many lodged at Savin Rock until it burned to the ground in 1934.

Laff in the Dark, farther down the road, constructed a white-faced clown head where cars could exit the ride. The entire facade was larger-than-life and colorful. As rides go, it was rather tame, a mix of painted canvasses and papier-mâché figures.

The most noticeable fun house had to be Death Valley, built next to the old Liberty Pier on Beach Street in 1937. Its first outside attraction lasted only a year, the owners feeling a skull and crossbones did not aptly convey fun and excitement. The following season "Laughing Sal" was added. Her signature laugh rang through the air from morning until 11 at night.

Scooters and bumper cars made their way to Savin Rock. Individual cars with thick leather seats ran along a slippery metal floor and were propelled by an electrical grid overhead. Gridlock may have been unheard of before the 1970s, but clusters of cars jammed together was one of the ride's drawbacks. When moving smoothly along, a sudden bump from another driver was sure to send a car off in an unexpected direction.

As the park's appeal diminished, newer rides were added, like the Wild Mouse, but one small addition did not have the power to defy a lagging popularity.

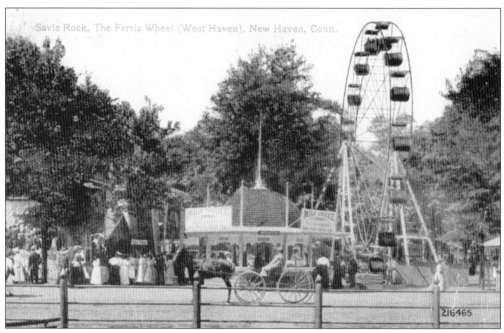

At least two Ferris wheels operated at the park each season. They rose three stories into the air and were easily dismantled.

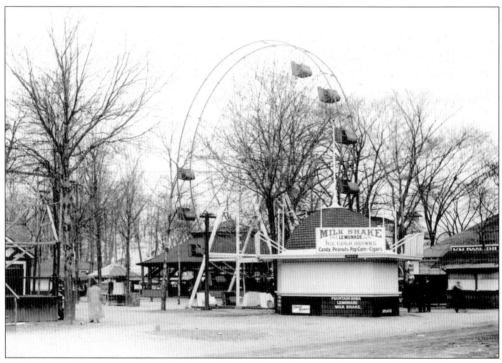

At the end of the season, the wheels could be dismantled piece by piece. Enterprising owners took them "on the road" for use throughout the South. When the snow thawed and the weather warmed, the Ferris wheels would begin another summer of operation.

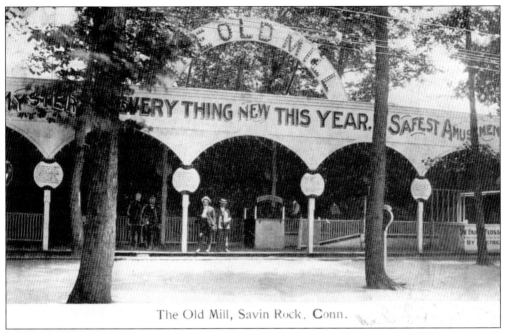

The Old Mill, Savin Rock, Conn.

One of the oldest rides at the park was the Old Mill. For a small fee, one could enter a small boat and ride through darkened canals. Within, lighted displays like Native American villages provided entertaining dioramas.

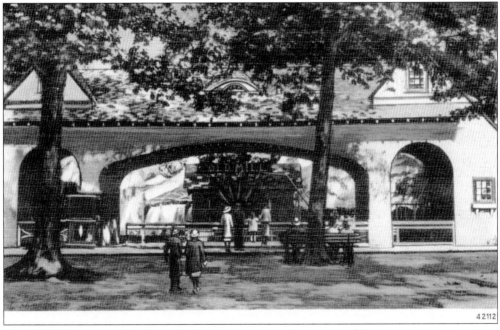

The Old Mill operated in the park for many years and was one of the more tame attractions. At its essence, it was a tunnel of love, given the darkened conditions and the opportunity to squeeze together with surprise.

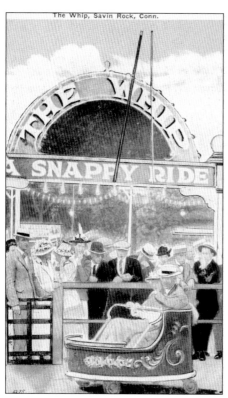

The Whip, Savin Rock, Conn.

It was larger rides, like the Whip, that provided thrills. Customers for this ride sat in cars and traveled an oval track. The smooth ride along the longest part of the oval came to an end when, as one reached the curve, the car snapped around with what seemed to be menacing speed.

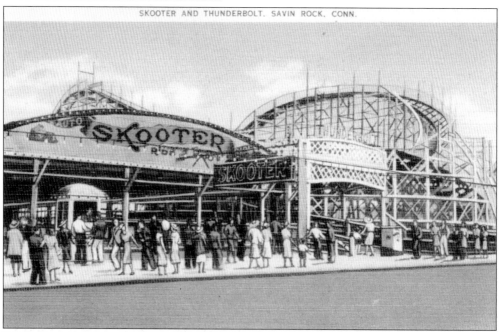

SKOOTER AND THUNDERBOLT. SAVIN ROCK, CONN.

Bumper car attractions enabled even the very young to drive, but the smashups that regularly occurred could jar teeth fillings. Riding along, small sparks spit out from the electric grid above, and nearly every turn contained at least one jam-up, forcing the attendant to slide across the floor to physically untangle the cars.

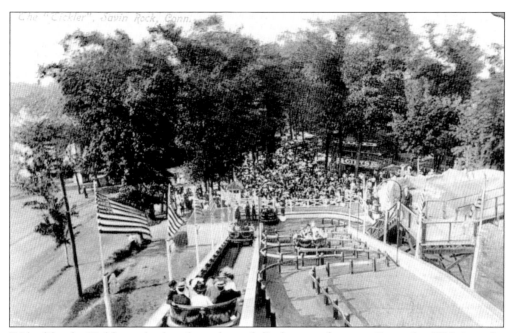

Rides like the Tickler and others kept the park lively year after year. From the 1920s into the Great Depression, the only drawback was fire. As with the Devil, fire consumed many of the vintage rides. Noah's Ark, the Mill Chutes, and the Virginia Reel all burned (the reel, however, was rebuilt).

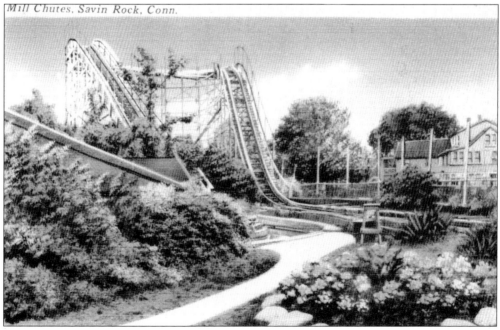

The Mill Chutes encompassed three distinct features: the darkened canal tunnel, an uplifting roller coaster, and a sharp splashdown.

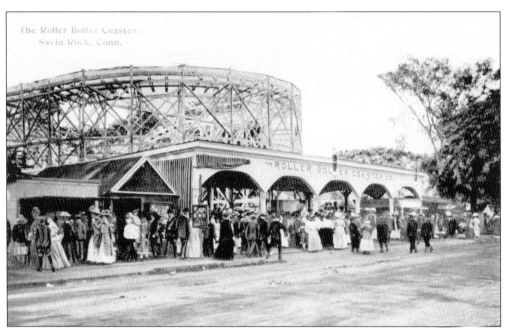

The Roller Boller was an early Savin Rock coaster made of white wood. This early ride had its beginnings during the golden years.

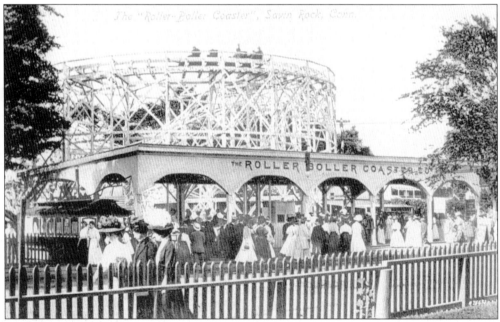

Like other wooden roller coasters, the Roller Boller needed steady maintenance. The weather along the shore is hard on exposed wood and repainting such a large, complex structure provided numerous jobs for summer help.

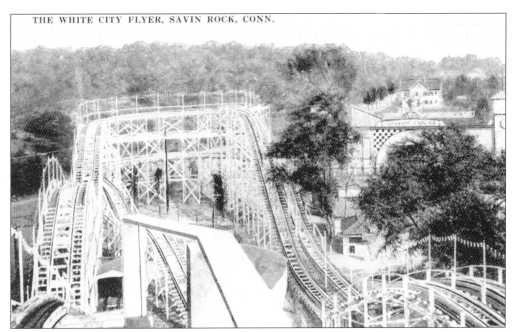

THE WHITE CITY FLYER, SAVIN ROCK, CONN.

The White City Flyer was another early ride that capitalized on the large crowds. With two coasters operating in the park, lines remained manageable.

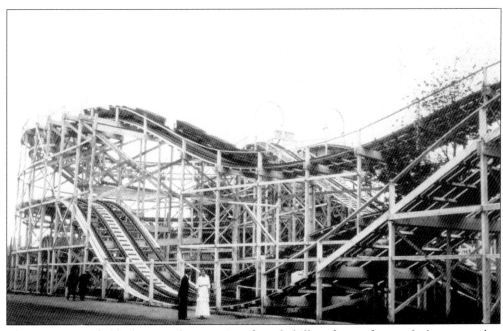

The Racer provided little more than a series of gentle hills, a far cry from today's coasters that spin cars completely over and travel at very fast speeds. This one was torn down in the 1920s.

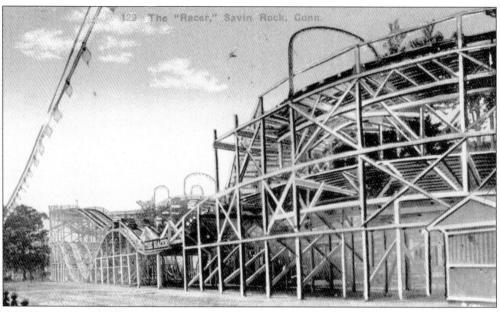

As roller coasters got larger and more complex, maintenance became a primary expense. As rides, they took up a lot of space.

Roller coasters are called "scream machines" and are all-time amusement park favorites. The ride generally begins with the cars being pulled to a high level. Once it is over the hump, the sudden drop develops the kinetic energy that drives the coaster along.

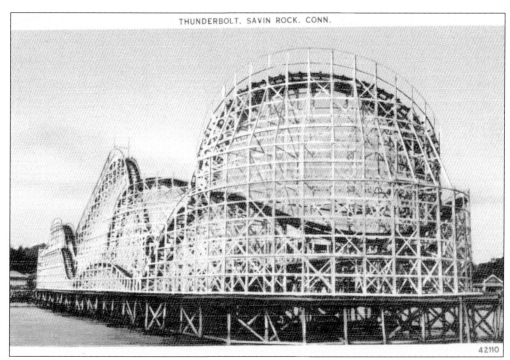

The Thunderbolt was constructed at Liberty Pier on Beach Street and stretched out over the water. Built by Prior and Church, it was erected in 1925 and lasted until it fell during the great New England hurricane of 1938.

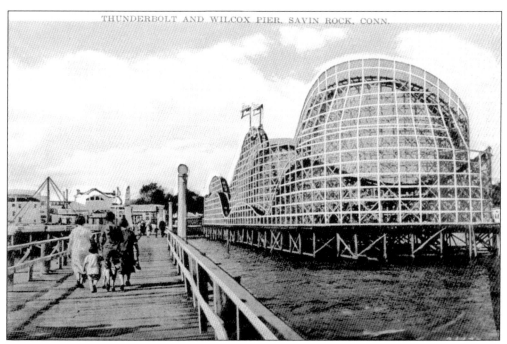

THUNDERBOLT AND WILCOX PIER. SAVIN ROCK. CONN.

Larger than most roller coasters of its day and featuring a "twist," the Thunderbolt provided plenty of thrills. The wood construction coupled with the sea breeze added a sway to the experience.

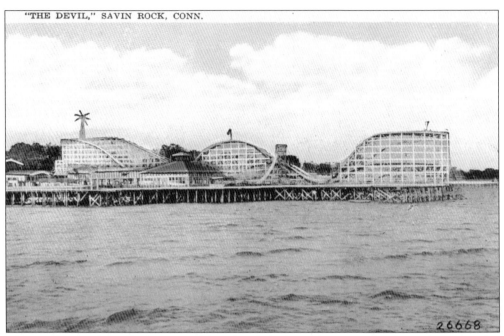

The Devil existed one block north of the Thunderbolt at Liberty Pier but burned in 1932 after only seven years of operation.

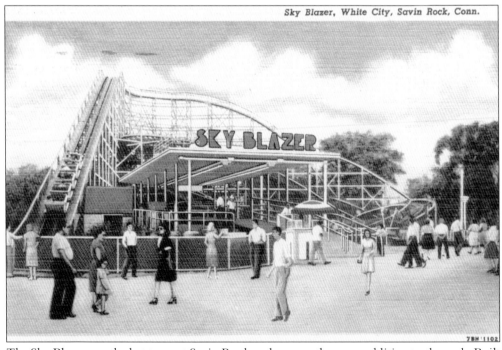

The Sky Blazer was the last to go at Savin Rock and was a rather new addition to the park. Built in 1946, it was the last roller coaster to go when the bulldozers came through in 1967.

Eight

ON THE WANE

The period of growth for the park ended after World War I, but the signs of Savin Rock's demise took decades to be fully revealed.

The good times of the 1920s were followed hard by the lean times of the Great Depression. Disposable income had dried up at about the same time that the park reached its peak of physical growth. No longer could it spread out along the shore or inward toward the town.

The makeshift quality of Savin Rock was spawned by a natural evolution and reusing old areas for new attractions, but even the popularity and steady success of Savin Rock could not withstand time forever. Outside factors came into play that proved too difficult to overcome.

Personal transportation supplanted mass transit, and the ferry and trolley lines suffered losses until their discontinuation. Automobiles crammed into every conceivable space along the narrow lanes within the park and extending out into the surrounding neighborhoods, creating a sense of frustration for the visiting patrons. No land remained available to assuage the glut.

Nearly equal to this was the sad fact that sanitation facilities were nearly nonexistent. The restrooms available were generally confined to individual restaurants and only open to patrons.

With fewer people visiting the park in the 1930s, the small cottages along Bradley Point fell into disuse, and until the 1960s, they and the Barnacle Restaurant began a slow slide into complete disrepair.

As a local attraction, however, Savin Rock continued to provide a respite from the travails of modern society and the activities at the rock mirrored what was happening across the country; marathon dances and live entertainment supplanted the more elegant dining establishments.

Wilcox's was no longer a haven for the very wealthy because the wealthy had moved on. Instead young couples came to dance the night away there and in other parts of the park. Headline entertainers often got their start in Savin Rock. Red Skelton, Doris Day, and local favorite Frankie Laine were familiar faces to the locals.

But Savin Rock had its dark side, and the want brought about by the Depression only exacerbated the gambling that went on behind closed doors. While bingo had been a favorite pastime in Savin Rock since the golden age, the post–World War II years saw a steady rise in illegal gambling and an increase in state police raids.

The days when wealthy students spent free moments at Savin Rock were gone as the 20th century progressed and money became scarce. The park shifted from being a tourist stop to a local entertainment center.

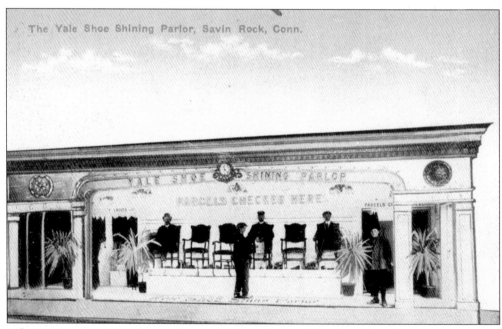

What is in a name? For the hundreds of Yale students visiting Savin Rock each summer, this shoeshine venue was an enterprising way of attracting people much in the way that Wilcox used his pier. Given its opulent design, this follows the architectural grandeur of the Colonnade that was owned by Yale Bishop. The Depression made this kind of service obsolete.

Early attractions of White City provided feature attractions like the Volcano. Entering a darkened room with special effects lighting up at passersby laid the foundation for the fun houses of later years. The newer varieties depended on a more surrealistic quality than an exotic setting.

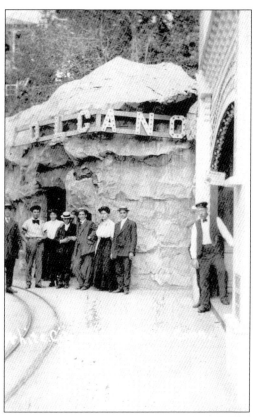

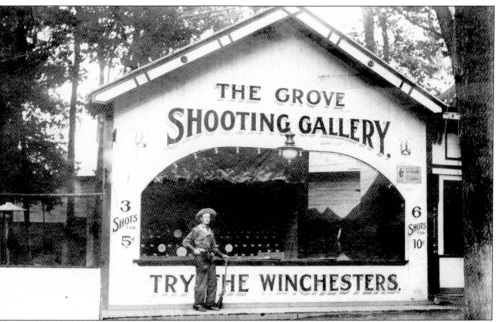

Meanwhile, out in the grove, local attractions strove to compete. This one advertised Winchester Repeating Arms, a successful New Haven concern. Until its end, shooting galleries were a Savin Rock staple.

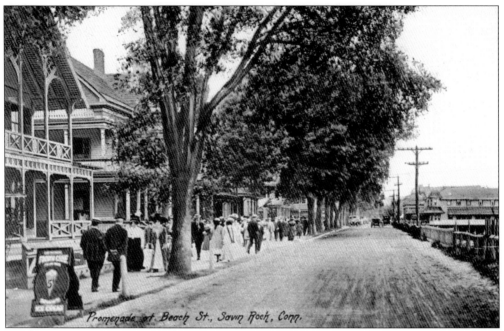

The days of quiet strolling passed. Beach Street became a congested site with a wide street lined with parked cars and narrow sidewalks with ramshackle games. Instead of fine dining, one spent time tossing balls at stuffed faces edged in horsehair or popping a balloon with a dart.

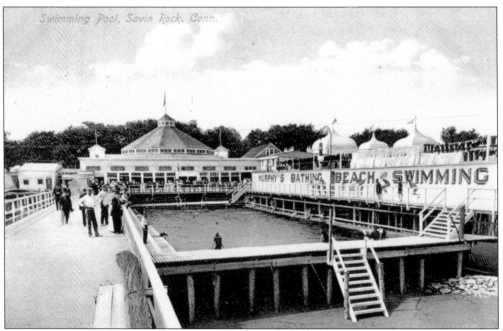

There were some attempts at large venues to bolster sagging numbers. Inground pools were not new to Savin Rock. This one dates to 1909. A growing pollution problem in the harbor made pools a more palatable alternative to tourists.

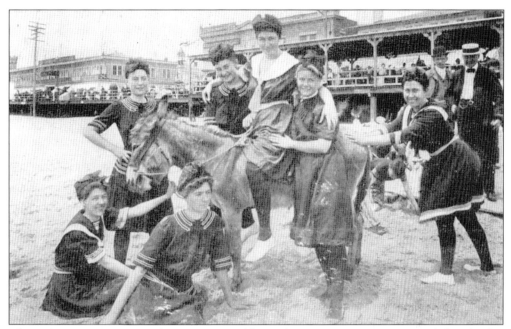

The early years at Savin Rock were a time of fun and prosperity. Americans reveled in the fun spent in the water and the unexpected surprises Savin Rock had to offer. At a time when horses pulled wagons along Beach Street, animals had their place at the park. Col. George Kelsey first introduced a small zoo, a monkey cage existed up until the end, and individual animals like this docile burro provided a photographic prop.

The area was proud of itself and boasted its fine architecture, notable schools, and opportunity. Savin Rock was one component of making the New Haven area a well-rounded community.

The years of the park's service were recorded. Postcards provided a more formal look at the park but personal photographs—many of them converted into real-photo postcards—were a mainstay for the tourists. It was not unusual for photographers like L. C. Krooner to have a seasonal stand at Savin Rock.

Savin Rock held a special place in many hearts. Those who visited had hours of fun strolling through the grove, riding the numerous amusements, dancing, and eating near the water. For those living near Savin Rock, it was a place of prosperity. Whether one was 16 and taking tickets for a ride or selling something through a kiosk, Savin Rock provided the opportunity to do well.

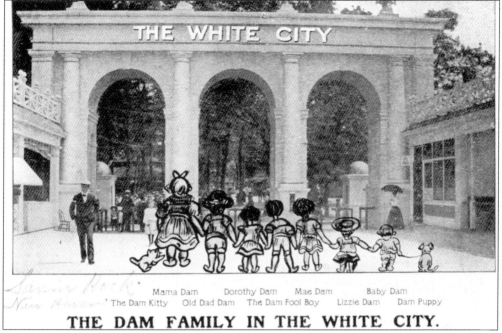

Mama Dam Dorothy Dam Mae Dam Baby Dam
The Dam Kitty Old Dad Dam The Dam Fool Boy Lizzie Dam Dam Puppy

THE DAM FAMILY IN THE WHITE CITY.

From the White City to the grove to Jimmies, Savin Rock represented family fun. In this case, the Dam family happens upon something great and unexpected—just what the promoters wanted Savin Rock to be.

Savin Rock was not unique. Parks sprouted up across the country that had all the components found in West Haven. They shared similar goods, similar attractions, and a similar form of good-natured fun.

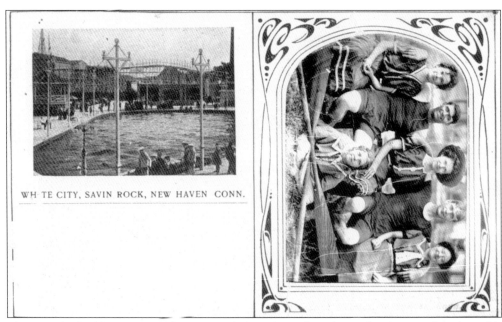

WH TE CITY, SAVIN ROCK, NEW HAVEN CONN.

Photography had been a part of Savin Rock from its earliest days. The tintypes found on this page were done at the White City. The cards were premade with scenes from the park and a frame to one side. The final photograph was slipped into the card of choice.

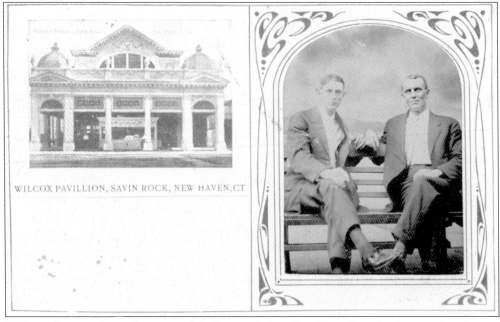

WILCOX PAVILLION, SAVIN ROCK, NEW HAVEN, CT

Various photographers who stamped their name below the picture bought the preprinted paper frames in large quantity. The framed photographs could now be mailed as postcards.

Group photographs commemorated special occasions. Anniversary parties, family reunions, and work picnics brought clusters of people into the park. The ease of photography allowed those times to be recorded.

Whether it was an informal gathering or those that required Sunday best, the common aim was to remember a special time. Among those groups regularly visiting Savin Rock, Yale alumni held their reunions at either Wilcox's or the Colonnade.

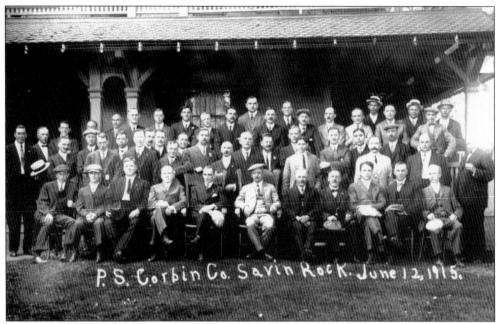

Even workers donned their Sunday best for a day at Savin Rock. This group poses in June 1915 and wears suits and hats.

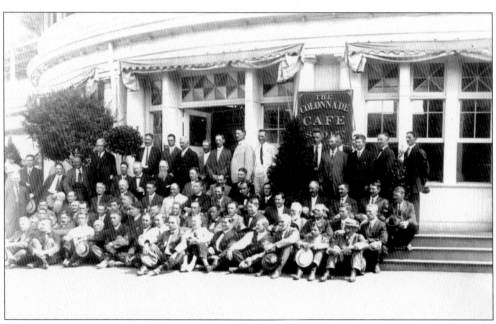

Restaurants at Savin Rock were designed to accommodate numerous diners, but places like the Colonnade provided elegant backdrops for photographs. This large gathering took advantage of the three steps leading into the main lobby.

From the young to the old, Savin Rock was a pleasant day away where one could sit and eat fresh seafood. This group at Wilcox's could wander next door for a quick spin on the merry-go-round before heading home.

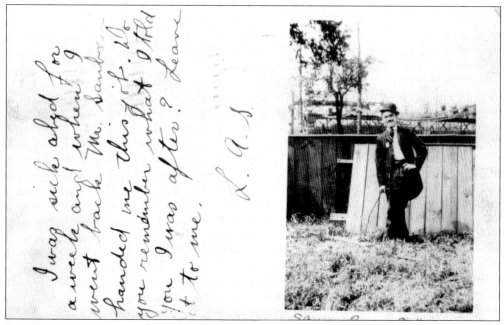

Aspiring actors and entertainers filled the park throughout the season. This vaudevillian poses Charlie Chaplin–style for a postcard to send home.

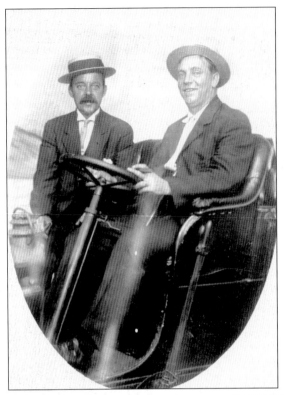

Mitchell's Studio provided an automobile as a prop. While the gentlemen in their straw skimmers look right at home, the woman in the polka dot dress was less so. This early photograph was taken at a time when the sight of a woman behind the wheel was considered unnatural and unladylike. The car as prop was easy for a photographer who owned one. It was a lot less cumbersome to use a freestanding prop than having to hang painted backdrops that looked fake. It is not surprising that these are Mitchell photographs, after all, Mitchell's was the car service within the park.

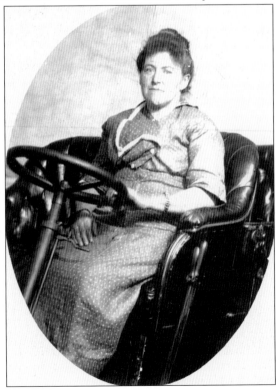

Props provided a less formal backdrop, and they came in many selections. This family found itself leaving on the Union Pacific. The props were canvas, wood, or paper painted in a rough style in two parts. The front part was lower and stood waist high; the background was on another.

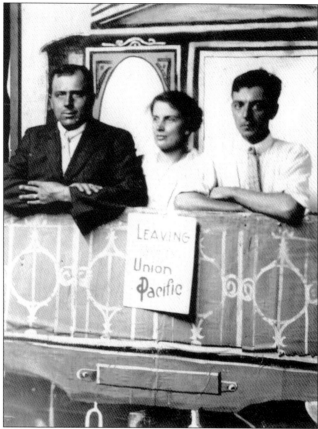

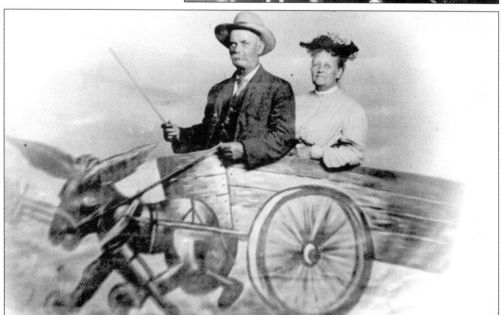

Though the park stood by the sea, many of the scenes were not nautical. This dour couple looks ready for a landgrab out West.

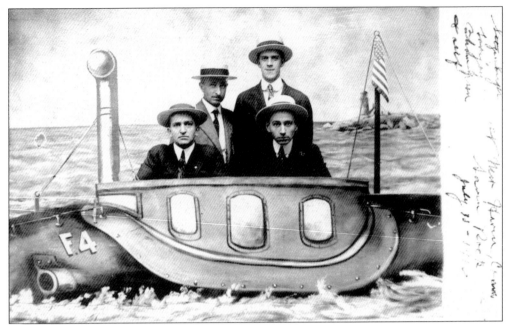

One of the favorite views for both men and women was the submarine. The men in skimmers look ready to launch in their mighty F4. These photographs were printed as postcards that could be sent home to family and friends.

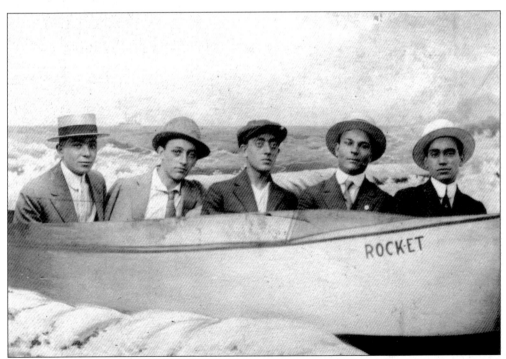

These five friends look like they are ready for a stop at the pub rather than a speeding boat. Group shots like this provide a good look at leisure attire of the period. For this crew, high starched shirts, skimmers, and snap-brim hats were de rigueur.

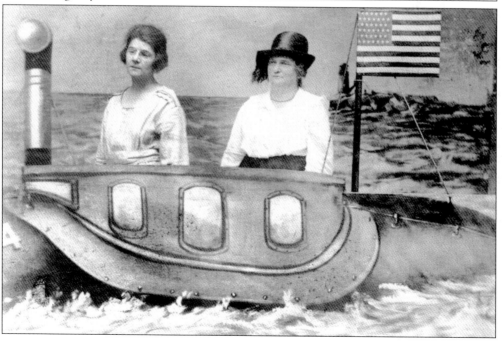

These two postcards feature the same women, possibly mother and daughter. While the mother wears identical outfits in both photographs, the daughter sports two different cotton summer dresses. In both cases, the postcards were unused and kept as mementos of a day at Savin Rock. The whimsey of the setting did not seem to effect the women. One might assume the dog days of summer and no air conditioning may have been a factor.

Grove Photo Gallery used a larger car ample enough for families. At this time, photography was not commonplace, and sitting for a portrait was serious business.

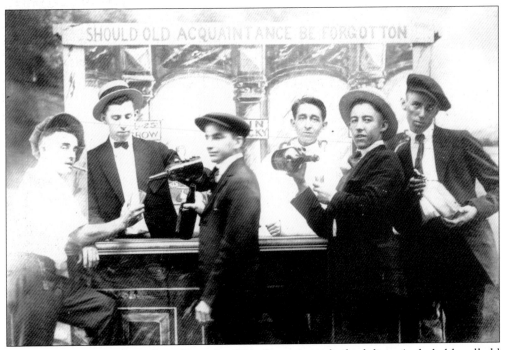

This merry group seems right at home in 1921. Over time, the backdrops included handheld props like the bottles and seltzer dispenser. These boys look ready for a night on the town. If they got too wild, Savin Rock had its own lockup on the premises.

In 1912, when this group portrait was taken, photographs were a big deal. Home cameras were not commonplace, and a memento like this was treasured and preserved. Despite the lack of toothy grins, real-photo postcards evoked fond memories of a happy occasion.

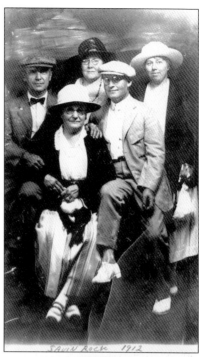

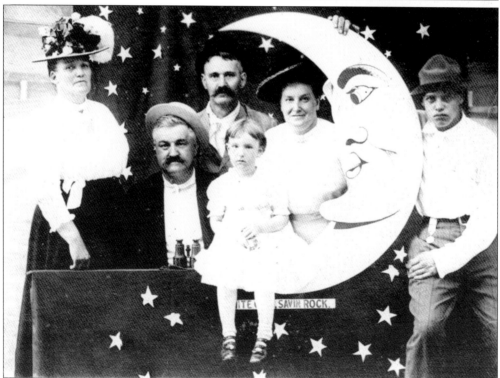

A day trip to Savin Rock was special. Nearly four generations visited the place throughout its life span. It is likely that this little girl sitting on the moon was an elderly woman when Savin Rock was razed.

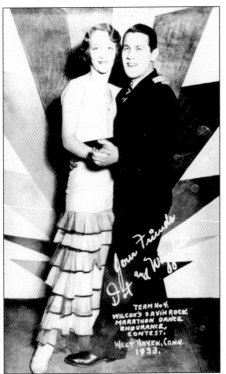

By 1933, when this photograph was taken at Wilcox's, the technology of photography was commonplace, and people posing appeared more relaxed. Dot Hopkins and Wiggles Royce, featured here, commemorated their participation in a dance marathon with a real-photo postcard. The contest took place in 1933 during the height of the hard times when the promise of money prizes enticed people to spend grueling hours on their feet.

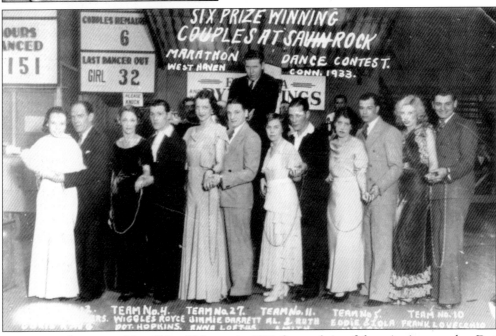

Dance marathons were big affairs. This one in 1933 featured six of the winning couples. Dot and Wiggles appear second from the left. To the far right is 20-year-old Frank Lovecchio, who toured the marathon circuit throughout the Depression. His singing career brought Lovecchio more recognition and cash. Lovecchio changed his name to Frankie Laine and went on to earn 21 gold records.

Nine

URBAN RENEWAL

Urban renewal of the mid-1960s extinguished the lights at Savin Rock. Large modern highways bypassed the shoreline, and shopping plazas formed farther inland on the Boston Post Road. Despite regular attempts to rejuvenate itself, it did not take long for the aging amusement park to find itself the target for improvement.

Severe traffic congestion clogged Beach Street and Ocean Avenue. Water pollution took its toll on the shoreline community. The fishing and oyster industries died out, and clamming was banned for health reasons.

The hurricane of 1938 and the one-two whammy of Hurricanes Connie and Diane of 1955 both undercut Beach Street and washed property away. Power lines were downed, and tidal surges flooded homes and eroded beaches. Twenty inches of rain pelted Connecticut. Rainwater met with the surging tide, and massive flooding occurred along the shore that caused millions of dollars in damage.

By 1967, bulldozers driving over Beach Street left a leveled plot in their wake. What had been an area of weathered stalls, drafty barns, and rotting pylons was now empty space. The crowds that once filled the area were gone. Before 1966, no one could imagine a summer without Laughing Sal or the flying horses.

Many of those who grew up with Savin Rock memories ask why things had to change. There are many answers. A severe shortage of sanitary facilities, lack of highway access, and the disuse of mass transit were contributing factors. But the real answer is one that Col. George Kelsey would understand. Americans love change. They are a people who always seek out the new and demand more by way of entertainment. Savin Rock was a place that grew with its times until it could grow no more. Cities, companies, and families suffer this same hardship. Everything has its life span, and for Savin Rock, that was nearly 100 years.

The park lives on in a newer guise, but the fundamentals of its attraction remain as vivid today as when Kelsey first walked the undeveloped shore. It is a sociable place for people to converge for a period of happy communion in a very pleasant environment.

Memories of grander times still linger. The Savin Rock Park Museum provides a wonderful display and the murals adorning Jimmies dining room convey the gaiety and flourish of Savin Rock in its prime.

When a new century dawned at Savin Rock, young couples could still walk the grove along Lover's Lane toward the water, spending idle moments away from life's cares.

Savin Rock Park was one of the first amusement parks of its kind but was soon joined by others across the nation. The 20th century began with great expectation. People seemed to have one foot in a world of technological improvements that promised an easier, more leisurely life. The other foot remained in an older world of the Wild West and living off nature.

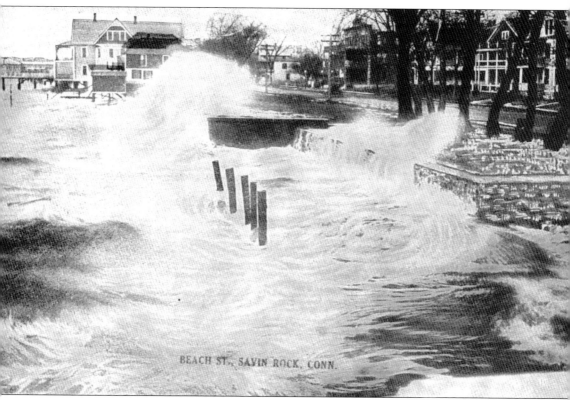

BEACH ST., SAVIN ROCK, CONN.

Fire may have provided the greatest threat to the park from its inception until the 1930s, but the great hurricane of 1938 did more lasting damage. Twenty-foot waves undermined the street, washed away many of the buildings along Beach Street, and put the Thunderbolt to rest.

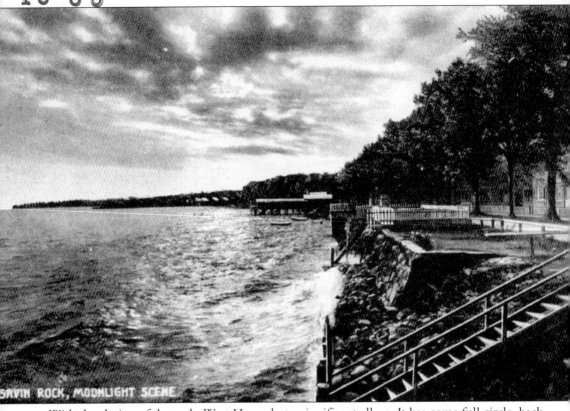

SAVIN ROCK, MOONLIGHT SCENE

With the closing of the park, West Haven lost a significant allure. It has come full circle, back to a tranquil setting by the sea, to a time when the water was the most prominent draw.